M000267666

IMAGES
*of Rail*

# RAILS AROUND
# THE THUMB

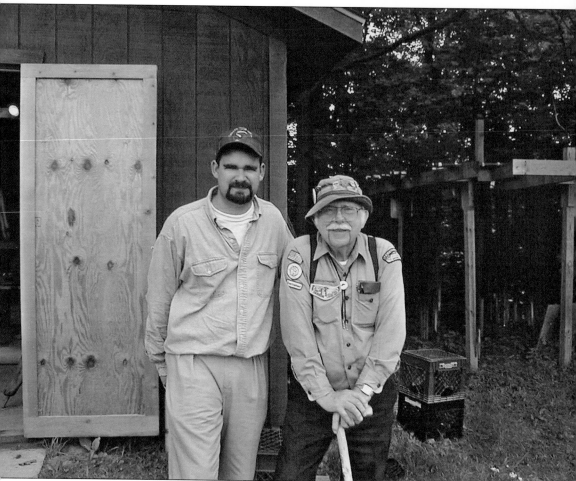

This photograph shows the author, Thomas Jay "T.J." Gaffney, with Orville Swick at the Silver Trails Boy Scout Camp near Jeddo, Michigan. Orville, who worked for the Pere Marquette (PM) and Chesapeake & Ohio (C&O) Railways from 1941 to 1983, spent most of his working life in the Thumb region. The author's interest in the Pere Marquette Railway and his eventual choice to become involved in the restoration and operation of steam locomotives is in no small part thanks to Orville's tales of his experiences working on the rail lines of the Thumb.

ON THE COVER: The crew of No. 5038 rest at Bad Axe with the last Grand Trunk Western (GTW) train to run from Cass City on April 30, 1951. This line was originally built by the GTW as the Detroit & Huron (D&H) Railroad and was designed to connect the GTW with the rich agricultural land served by the Pere Marquette Railway lines that intersected at Bad Axe. Finished in August 1913, the D&H branch was never a huge moneymaker, and it came as no surprise when the branch closed 38 years later. From left to right are George Wix (engineer in the cab), conductor George Morgan, retiree Jack Muntz, brakeman George Boyd, and brakeman Al Hasse. (Photograph by Bill Miller.)

IMAGES
*of Rail*

# RAILS AROUND THE THUMB

T.J. Gaffney, with an
introduction by Kevin P. Keefe

ARCADIA
PUBLISHING

Copyright © 2012 by T.J. Gaffney
ISBN 978-0-7385-9216-9

Published by Arcadia Publishing
Charleston, South Carolina

Printed in the United States of America

Library of Congress Control Number: 2011938711

For all general information, please contact Arcadia Publishing:
Telephone 843-853-2070
Fax 843-853-0044
E-mail sales@arcadiapublishing.com
For customer service and orders:
Toll-Free 1-888-313-2665

Visit us on the Internet at www.arcadiapublishing.com

*To Orville Swick, who is the embodiment of everything that is good about those who worked for the railroads; and my good friend Gareth McNabb, who passed away while I was writing this book.*

# CONTENTS

# ACKNOWLEDGMENTS

Nearly five years have passed since my first book, *Port Huron 1880–1960*, was published. At that time, I had just completed six years as curator of the Port Huron Museum and was hired as the executive director of the Steam Railroading Institute (SRI). To say this was a dream come true was an understatement, but it also proved to be one of the most challenging moves of my career. It is fitting then that this book starts a new adventure, which gives me more time for my family and reminds me that life is not just about the attainment or management of money, but also of friendships, one's family, and one's soul.

While it is impossible to thank everyone who gave support to this project, three people have gone out of their way to keep me "on the right track." The first is "Freighter" Frank Frisk for his unfailing support, and his ever-flowing cups of coffee at Boatnerd Headquarters did not hurt either. Second, thanks to Suzette Bromley, who helped with the scanning and insisted that I write another book. Finally, thanks to everyone at the Cavis Grill, but most especially Nick Cavis. I joke that Nick should charge me rent for the corner booth that is my second office. Nick, you rock, bud.

There are also many who influenced this book through their camaraderie and shared enthusiasm for rail history. Specifically, I wish to thank Barney and John Gramling, who reminded me why family and sense of place is important; Bob and Jane Diehl, in many ways my spiritual advisors with this project; to all of the dedicated volunteers of SRI during my time there; George Y. "Sandy" Duffy Jr. for his continued reminders of why history is important; John Barnett for his always open ear; and Chad Thompson, Greg Udolph, Jodi Hak, Justin "Jugger" Hamilton, Kim Lazar, Nancy Barnes, and Sue Grieve for their tireless effort given to me and SRI while working there.

Finally, thanks to my wife and best friend, Heather, who has decided to ride this wave we call life with me. I love you, hun.

Unless otherwise noted, all images are from the author's personal collection.

# INTRODUCTION

Michigan is proud of its status as a peninsular state, surrounded on almost all sides by four of the Great Lakes. That geographical fact has driven the state's history, its economy, even its sense of self. It has also driven its railroad history. As the first railroads began arriving in the Midwest in the 1840s, Michigan found itself slightly off the beaten track. The vast majority of interstate, trunk-line freight, and passenger traffic went east-west through Ohio and across northern Indiana. To go through Michigan was to go, well, out of the way. For the most part, the New York Central (NYC), the Pennsylvania (PRR), the Erie (ERIE), the Nickel Plate, the Baltimore & Ohio (B&O), and just about any other east-west trunk line said, "No thanks."

It is not that the Great Lake State lacked its main lines. The sheer muscle of heavy industry in the southern part of the state—fueled by automobile manufacturing—required a number of heavy-duty railroads, notably the Michigan Central between Detroit and Chicago, the Pere Marquette linking Detroit with Toledo and Grand Rapids, and the Grand Trunk Western, southern Ontario's bridge to Chicago and Detroit. For generations, these interstate railroads were known for heavy-duty freights and prestigious passenger trains.

More often than not, though, Michigan had to grow its own railroad system to serve its needs. And that is where one of the state's greatest geographical curiosities—the Thumb—comes in. Although it was circumscribed by the main lines of the PM to Flint on the west and the GTW to Port Huron on the south, the Thumb's interior was a homegrown affair. With their flat-as-a-pancake terrain and rich, black soil, the counties of Huron, Sanilac, Tuscola, Lapeer, and St. Clair evolved into a rich agricultural region known for sugar beets, navy beans, and corn. Although much of Michigan's early railroad building served the timber industry, the farm eventually held sway, especially in the Thumb.

The Thumb's lifeblood was the Pere Marquette, which practiced a classic Midwestern style of railroading exemplified by trim little PM 2-8-2s in the steam era and truly rare BL2 branch-line diesels in the early diesel days after the Chesapeake & Ohio acquired the railroad in 1947. The PM did much of its business in the bustling railroad towns of Bad Axe, Vassar, and Port Huron. The big-time action of PM 2-8-4's out of Saginaw was mostly a distant thunder. In the Thumb, PM rolled with very little urgency. After all, one could only go so far before running into Lake Huron!

The Thumb was not all Pere Marquette. Grand Trunk Western, Michigan's other home Class I, was a fixture in the region. Emblematic of the GTW was the Cass City Subdivision, which reached from Pontiac all the way to Saginaw Bay. It was a stomping ground for the railroad's classic light 4-6-2s and 2-8-2s. Two Pacifics in particular, Nos. 5038 and 5043, came to be associated with the sub, traipsing in front of photographers' lenses with some regularity. Over in Port Huron, the GTW yards were the domain of US Railroad Administration (USRA) 0-8-0s, a famous brood of switchers, some of which immigrated in later years to Northwestern Steel & Wire in Sterling, Illinois—exports from the Thumb, so to speak.

Other railroads make their way into this absorbing book. The state's eponymous Class I, the lordly Michigan Central, dabbled in the Thumb with its Detroit–Bay City main line and the Vassar-Owendale branch via Caro. Thus, the region did see occasional royalty in the form of NYC's peerless 4-6-4 Hudsons and somewhat more humble RDC "Beeliners" in the 1950s. And one should not overlook the Handy Brothers heritage railroads: the Detroit, Bay City & Western (later the Detroit, Caro & Sandusky) and the Port Huron & Detroit (PH&D). The former probably should never have been built; the latter lasted until 1984, a bastion of ALCO diesels sending its trademark blue boxcars all across the United States.

Today, railroading in the Thumb remains a rather prosperous affair thanks to the decades-long service of the Huron & Eastern Railway (H&E), one of America's more steadfast short lines. The H&E was one of the pioneering companies of the short-line and regional-railroad boom that came in 1976 in the wake of Conrail's organization that year. The railroad thrives 36 years later thanks to smart management and a carefully cultivated customer base. The big main-line trains near the Thumb continue, as well, to roll over on CSX in the west and on Canadian National to the south, loaded as ever with the material of the automobile industry.

Meanwhile, we have in T.J. Gaffney the ideal author—a professional historian and preservationist with top credentials in the world of Michigan railroading. He has worked in Michigan for years, including in Port Huron. He knows his PM from his PH&D, his Bay City from his Imlay City. With T.J. as your guide, you will enjoy an entertaining and flavorful trip aboard the trains of the Thumb.

—Kevin P. Keefe, publisher of *Classic Trains Magazine*, Milwaukee, Wisconsin

# One

# HURON COUNTY

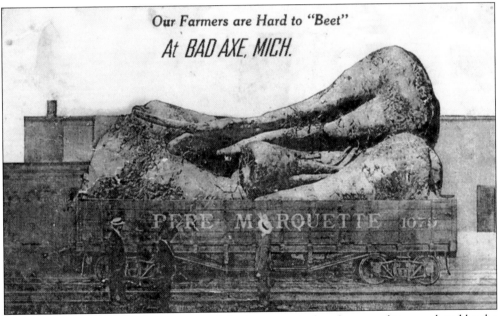

Our Farmers are Hard to "Beet"
At BAD AXE, MICH.

This humorous postcard references one of the largest agricultural commodities produced by the Thumb and a huge a source of traffic for railroads in the region to this day: the sugar beet. It was introduced to the region by Dr. Robert C. Kedzie, professor of chemistry at Michigan State Agricultural College (now Michigan State University), to replace the loss of the lumber industry after the devastating fire of 1881. The sugar-beet plant is a root crop, which grows underground, weighs two to five pounds, and produces about three teaspoons of sugar when fully grown. Michigan farmers harvested 130,000 acres of the crop in 1996, ranking Michigan fifth in the nation in sugar-beet production. The state's Saginaw Valley and Thumb area along with the southeast corner of the state produce more than 90 percent of the sugar beets grown east of the Mississippi River.

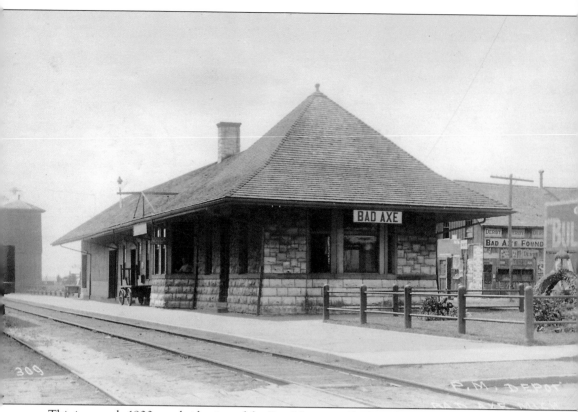

This is an early-1900s trackside view of the Pere Marquette Railway depot at Bad Axe. Originally located at the intersection of two Pere Marquette Railway predecessors—the Port Huron & Northwestern (PH&NW) Railway and the Saginaw, Tuscola & Huron (ST&H) Railway—Bad Axe was an important division point for the railroad; hence the unusual use of stone for construction materials in comparison with the other depots of ST&H and PH&NW construction.

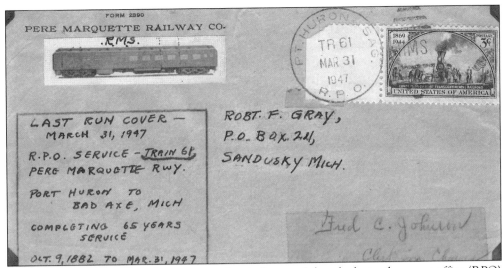

This envelope represents the beginning and end of an era. It has the last railway post office (RPO) cancellation for Pere Marquette train No. 61 after 65 years of service. The RPO was a dedicated railway car operated in passenger service as a means to sort mail en route to speed delivery to communities along the line. RPO service on these lines began with Pere Marquette predecessor PH&NW on October 9, 1882, and ended March 31, 1947. Less than three months later, the Pere Marquette would be gone as well, merged into the Chesapeake & Ohio.

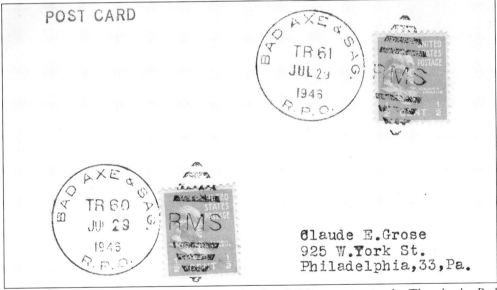

This is the final cancellation for the second-to-last RPO operation in the Thumb, the Bad Axe–Saginaw RPO, dated July 29, 1946. At their height, RPO cars were used on over 9,000 train routes covering more than 200,000 miles in North America. By 1946, there were less than 800 RPO lines operating over 165,000 miles of railroad. In September 1967, the US Postal Service cancelled all "rail by mail" contracts, electing to move all first-class mail via air and other classes by road (truck) transport, effectively throwing previously profitable passenger services instantly into the loss column and putting thousands of RPO clerks out of work. After 113 years of railway post-office operation, the last surviving railway post office running on rails between New York and Washington, DC, was discontinued on June 30, 1977.

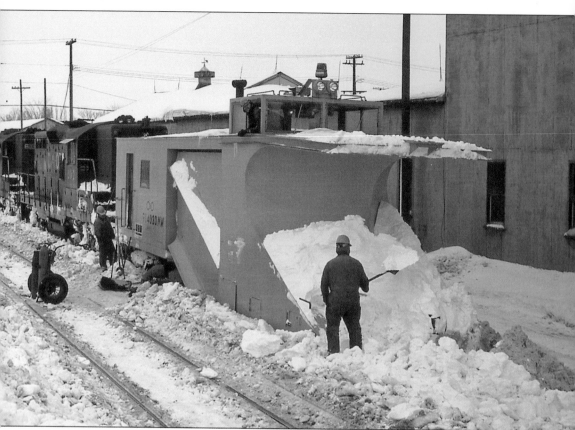

It is the early 1980s, and the crew of the Chessie System plow extra has already had a long day; however, it is not over. The crew is in the midst of cleaning off and repairing its snowplow for another battle with the lake-effect snow of Michigan's Thumb. Evidently, the last plow run did some damage to its underside, as the crew has the welder out to make repairs. Soon, this portion of the railroad would be sold to the Huron & Eastern Railway, beginning an empire that would grow into what is now the RailAmerica Corporation. (Photograph by Jeff Mast.)

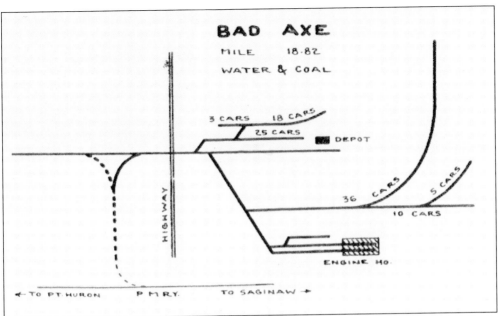

This map shows the layout of the Grand Trunk Western facilities at Bad Axe around 1945. As can be seen in the sketch, a wye connected the Pere Marquette Railway's Port Huron–Saginaw main line with the GTW's Cass City–Bad Axe branch (known as the D&H), allowing GTW (much like the PM) to have the ability to turn a locomotive or a complete train around without the need for the expensive installation of a turntable. All of this would be gone by the early 1950s with GTW abandoning its branch back to Cass City in early 1951.

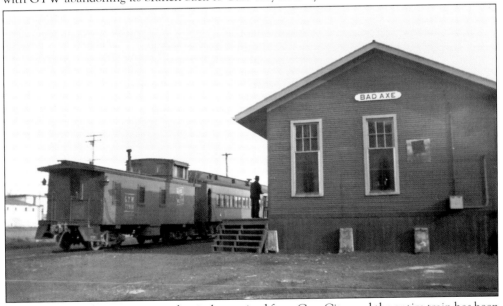

The Grand Trunk Western mixed train has arrived from Cass City, and the entire train has been wyed in preparation for the return trip. A solitary passenger awaits the departure, which helps explain the GTW's earlier abandonment of the D&H sub. The consist is a typical mixed-train arrangement of a GTW 77000 Series wood caboose and a 7200 Series steel combine serving as the passenger portion. (Photograph by William J. Miller.)

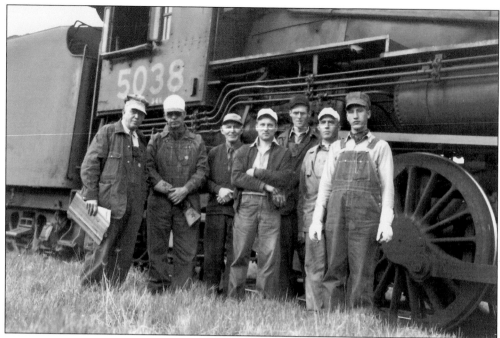

It is April 30, 1951, and the crew of the last GTW train into Bad Axe poses with its locomotive, Class J-3-a Pacific-type No. 5038, built by Baldwin Locomotive Works in 1912. From left to right are conductor George Morgan, George Wix, retiree Jack Muntz, Bill Miller, brakeman George Boyd, brakeman Al Hasse, and fireman George Walasky. (Photograph by William J. Miller.)

GTW retiree Jack Muntz (left) and conductor George Morgan pose with their combine on the last run. Usually accompanied by one of the GTW's ubiquitous wooden, morency orange cabooses, for whatever reason this train has none. (Photograph by William J. Miller.)

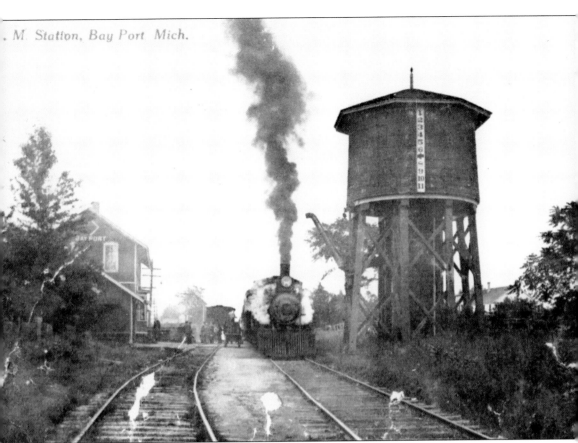

The daily train to Bay Port arrives behind one of Pere Marquette's 4-4-0 locomotives around 1910. Originally part of the Saginaw, Tuscola & Huron Railway, which the PM absorbed in March 1900, Bay Port and the branch that served it soon became an important source of income as an avenue to the fisheries of the Saginaw Bay region.

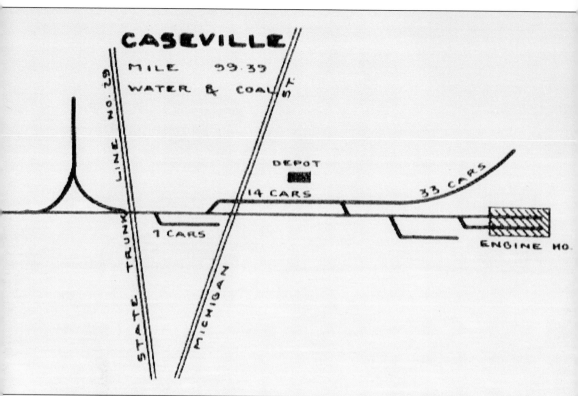

This map shows the layout of the Grand Trunk Western's trackage at Caseville at the end of the Cass City Subdivision. Much like Bad Axe, there was a wye for turning locomotives, but unlike Bad Axe, the legs of the wye were not long enough to turn the entire train. The engine house, located at the right on the map, was only two stalls and lay just beyond the depot. Up until the 1950s, it was not uncommon for a separate locomotive with a plow to run ahead of the regular mixed train, as the track would be covered several feet deep in snow.

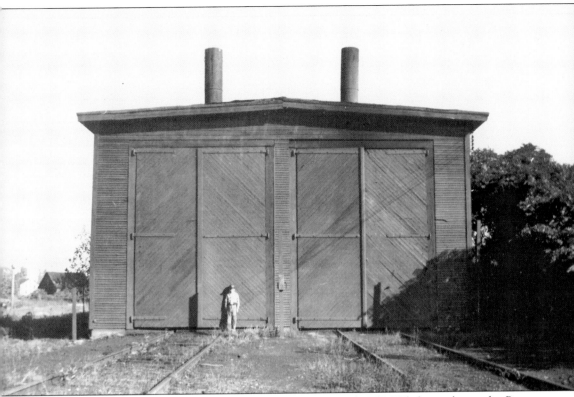

The two-stall engine house at Caseville appears here around 1950. While similar to the Pere Marquette's two-stall house at Bad Axe, this one had the advantage of having a small bunk area for the crew in a small loft. It was not, however, big enough for the remainder of the crew, who usually slept in the caboose.

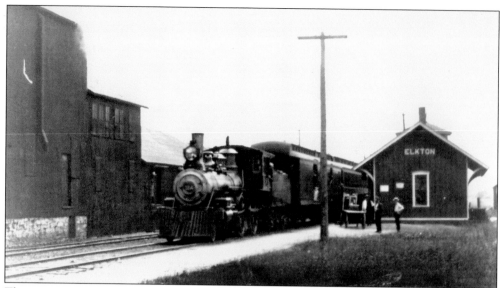

This c. 1910 image shows Pere Marquette Railway locomotive No. 124 approaching the Elkton depot with the twice-daily Saginaw–to–Bad Axe local. This locomotive was built by Manchester Locomotive Works, a predecessor to ALCO, for PM predecessor Chicago & West Michigan in 1871. It was scrapped, like many other PM predecessor locomotives, for the metal drives of World War I.

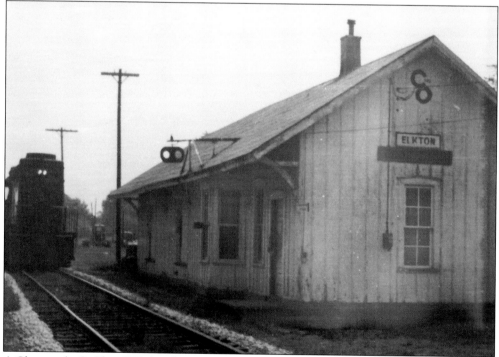

A Chesapeake & Ohio GP9 diesel approaches Elkton depot around 1970. Like many other depots in the Thumb, Elkton remained an active station agency longer than many others in the county, lasting until 1974. The depot was later purchased and moved into downtown Elkton and is now an antique store.

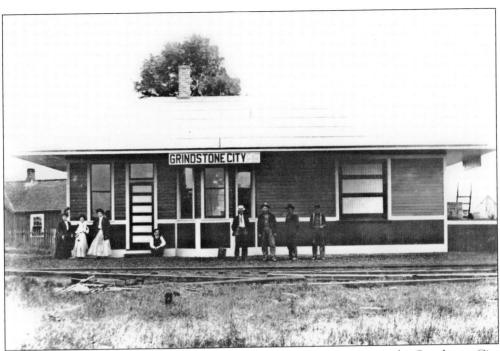

A group of local denizens waits for the morning train from Port Austin at the Grindstone City depot around 1905. Like similar stations built just after 1900 at Port Hope, Hemlock, and New Buffalo, Grindstone City is a standard design that contained a small waiting room, baggage room, and telegrapher/agent's office with a bay window.

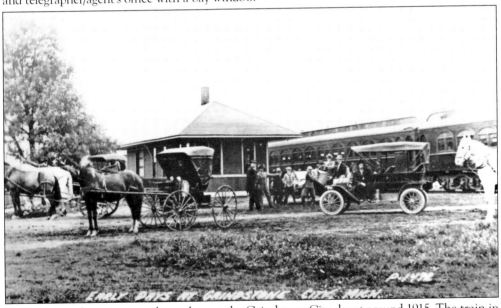

A transition of eras is seen taking place at the Grindstone City depot around 1915. The train in the back has passenger cars with more modern, closed-end vestibules, and amidst the horse and buggies sits a Ford Model T. Judging by the crowd, this is most likely some sort of holiday special to nearby Point Aux Barques, which is known for its geologic formations and cool breezes off Lake Huron to this day.

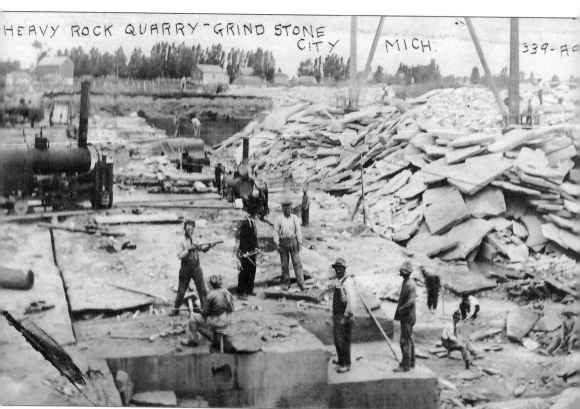

This image shows the real reason that Pere Marquette decided to extend its line from Port Austin to Grindstone City in the 1890s. Grindstone City, as its name denotes, once had a flourishing industry that produced the largest and finest grindstones, scythe stones, and hone stones in the world. In 1834, Capt. Aaron G. Peer was forced to find shelter in the natural harbor and noticed the quality of the stone he found there. In 1836, he bought 400 acres of land and began the quarrying and production of grindstones. In 1888, the Cleveland Stone Company purchased all the properties and quarries around Grindstone City and was shipping stones by rail as well as by boat by 1895. The advent of Carborundum by Edward Acheson, a student of Thomas Edison, quickly killed the industry, and the quarries closed by 1929 with the railroad abandoning back to Port Austin in 1932.

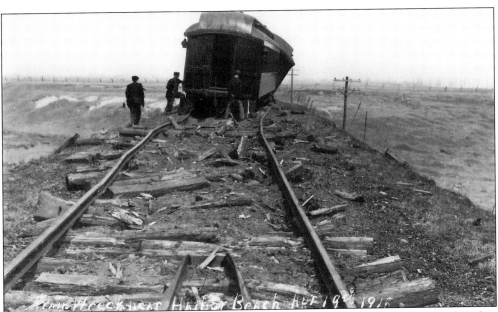

This photograph shows the aftermath of the Pere Marquette train wreck just south of Harbor Beach on April 19, 1915. According to reports, a portion of the roadbed saturated by an early thaw and several days of rain was undermined and gave way under the weight of the morning train. Although it did serious damage to equipment and the right-of-way, thankfully no one was seriously injured.

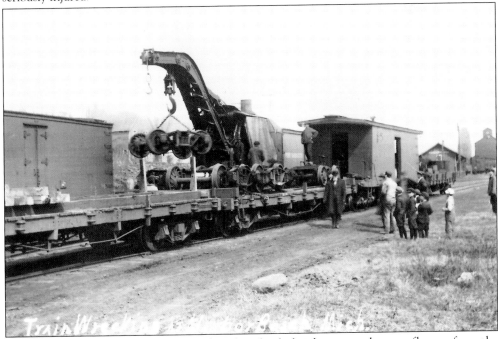

The Pere Marquette Railroad's steam derrick unloads freight-car trucks onto flatcars from the wreck shown above as local schoolchildren look on. The slightly smaller wheel set closest to the work outfit car in this photograph is likely the front truck to the locomotive, most often a 4-4-0 American type at this time period.

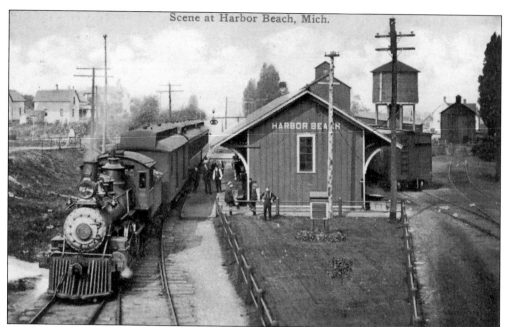

Built in 1872 by Manchester Locomotive Works for PM predecessor Detroit, Grand Rapids & Western, engine No. 102 appears with its three-car passenger train at the immaculately maintained Harbor Beach depot. This busy scene shows how important the railroad was to the area with nearly every spare section of track filled with cars. To the right is the one-stall engine house, dating this photograph to before 1903 when the extension north of here to Port Hope was opened.

Another one of the important customers for the Pere Marquette in Harbor Beach was Huron Milling. This view shows the operation at its height in the 1920s. Note the 15-bay, *L*-shaped garage for parking Model A's and the early steel cars with the wooden freight cars.

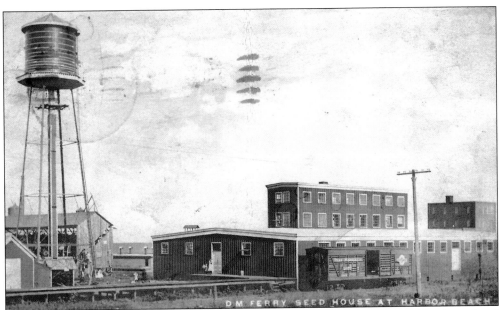

This view of the D.M. Ferry seed house shows one of the many customers served by the railroad in Harbor Beach. It also documents an extremely rare Pere Marquette stock car. Built as part of a 1903 order of cars from American Car & Foundry Company of Detroit, Michigan, car No. 2077 was constructed entirely of wood and reinforced with steel truss rods. Most of these cars were gone by the 1930s, dating this photograph to sometime in the 1920s.

Train time at Harbor Beach is a busy one. Locomotive No. 83, hauling the train on the far side of the depot, was built in 1866 by Schenectady Locomotive Works for the Flint & Pere Marquette Railway as the *Samuel Farwell*. Rebuilt in 1893, this locomotive worked for nearly 60 years before being scrapped sometime before 1920. The depot survives today as part of the Depot Motel just north of the city on M-25.

Known as the "Bean Capital of the World," Kinde is named for a man who in the early 1880s established a general store, lumber yard, grain elevator, and post office here. This image dates to the early 1950s, before the depot (on the right-hand side of the photograph) burned in the 1970s. The elevators here remain a large customer for the railroad and are the major hub for Michigan dry-bean farmers in the area.

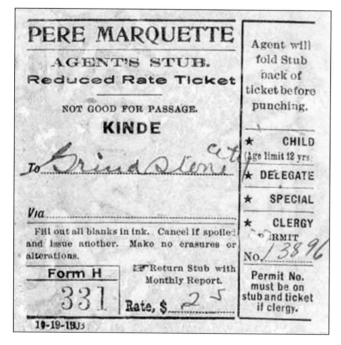

This is a rare image of a Pere Marquette ticket stub for passage from Kinde to Grindstone City sometime around 1910. A mere 25¢ could get passengers between the two points at that time. Interestingly enough, this one is stamped for clergy, who received a special fare.

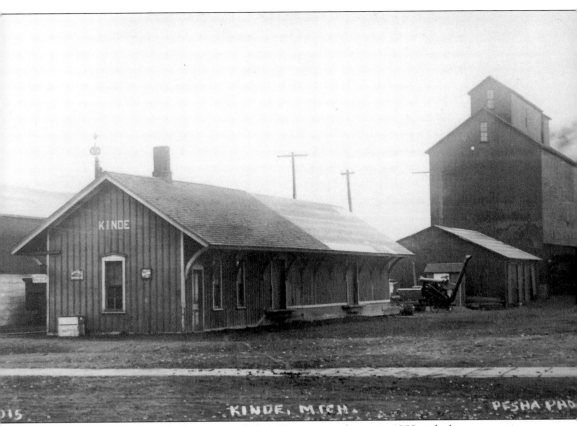

This image shows the Kinde depot around 1910. Train service began in 1882 with the construction of track by the Port Huron & Northwestern Railway, and it is the end of track for the Huron & Eastern Railway's Port Austin branch today. It is a near carbon copy of stations at Croswell, Harbor Beach, Ubly, and Ruth. This station is most unusual because of its longevity of service, retaining an agent well into the early 1970s. Sadly, the depot burned down in a spectacular fire after nearly 100 years of service. (Photograph by Louis Pesha.)

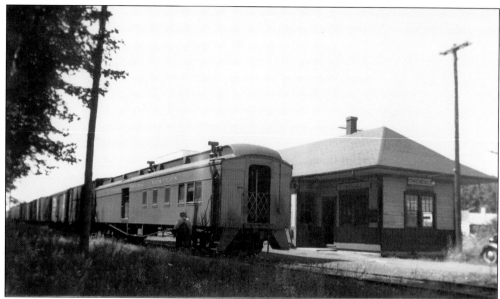

The daily GTW mixed train makes a stop at Owendale, which was an important junction point for two railroads: the Michigan Central/New York Central from Caro and the Grand Trunk from Imlay City to Caseville. By the time this photograph was taken, passenger service was getting pretty slim on the Grand Trunk end and was nonexistent on the New York Central side. (Photograph by William J. Miller.)

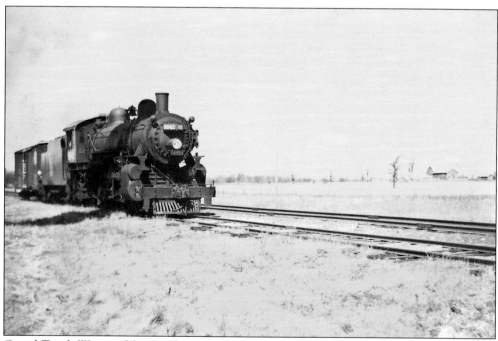

Grand Trunk Western J-3-a Pacific-type No. 5042 prepares to set off a boxcar for interchange with the New York Central at Owendale. Lightweight in construction and all built around 1912, these locomotives were used almost exclusively on the Polly-Ann in their later years. No. 5042 lasted until 1955, when she was scrapped.

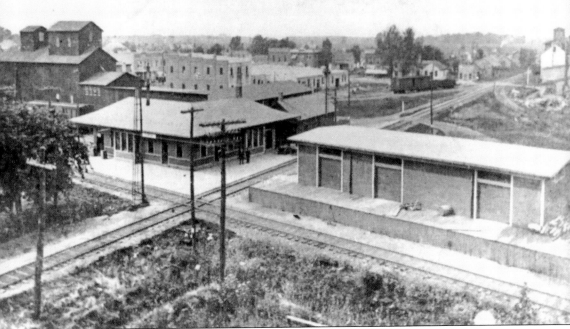

This is an early view of the joint Grand Trunk Western and Pere Marquette Railway station at Pigeon. What is unique in this photograph is the angle it is shot from; no one is quite sure where the photographer was standing to get the image—unless he was in a balloon. An important interchange point at the time this c. 1910 photograph was taken, Pigeon warranted a separate freight house from the passenger station. The track in this image runs east to Saginaw and west to Bad Axe; north and south are to Caseville and Imlay City, respectively.

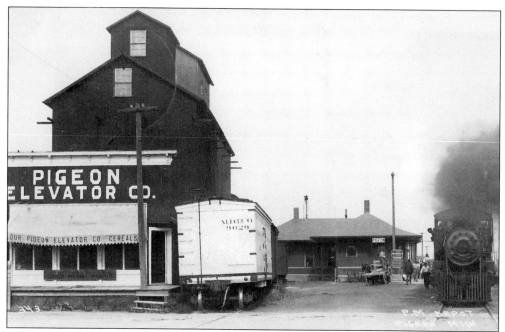

This is another photograph taken at Pigeon looking north toward the station. This shot was given to the author by the late Frank Koob, who indicated that it is the only image he has ever seen of a Michigan Dairy Transfer refrigerator car, which can be seen on the Pere Marquette siding next to the Pigeon Elevator Co-Op. Although not as large as some of the agricultural commodities shipped via the railroads in the region, the dairy industry did represent a significant source of income in several communities for the railroad, and Pigeon was no exception.

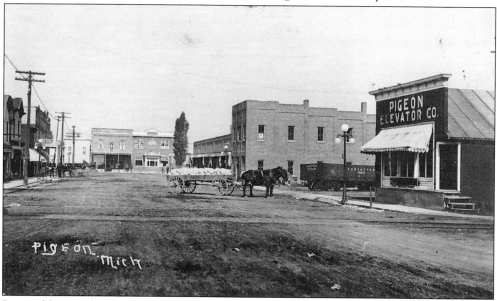

Pictured here is downtown Pigeon, showing both the main line and the entrance to the team track that ran behind the station. A sugar-beet gondola can be seen peeking out from behind the elevator, one of hundreds that could be found on the GTW and PM lines in the Thumb at harvest time.

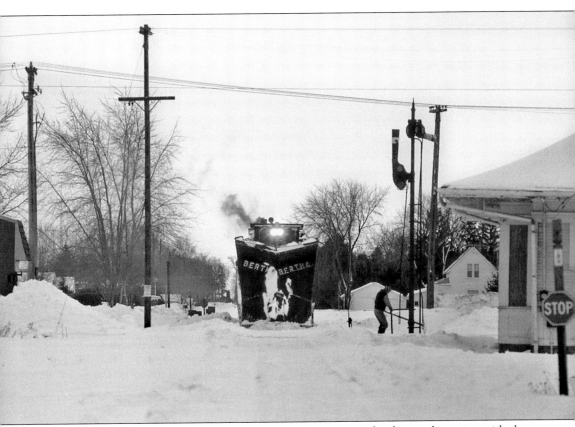

*Big Bertha*, the Grand Trunk Western's Jordan spreader, waits at the diamond crossing with the Chesapeake & Ohio at Pigeon. Always set against the Grand Trunk, the brakeman eases the gate, often called a "smash board," out of the way so the plow extra can continue on to Caseville. Both the spreader and the line itself are on borrowed time, as the line would be abandoned in 1986 and the spreader gone by 1994. (Photograph by Jeff Mast.)

# PORT AUSTIN BRANCH

**Northward**                                                    **Southward**

| THIRD CLASS | | STATIONS | FOURTH CLASS | | Miles from Bad Axe |
|---|---|---|---|---|---|
| 1013 | | | 1014 | | |
| Daily Ex. Sun. | | | Daily Ex. Sun. | | |
| P. M. | | | A. M. | | |
| 1.00 | | ..... *Bad Axe ..... | A 7.30 | | ..... |
| 1.30 | | .......Kinde....... | 7.00 | | 9.4 |
| A 2.00 | | .. PORT AUSTIN .. | 6.30 | | 16.0 |
| P. M. | | | A. M. | | |

This schedule denotes the 16-mile branch from Bad Axe to Caseville. By the time of this c. 1956 timetable, passenger service had ended, and by the 1980s the branch had been pulled back to Kinde, where it ends today.

Welcome to winter railroading in Michigan's Thumb! Taken in what is known as Pollock Cut between Kinde and Port Austin, this photograph shows just how deep the snow can get in this area. Each of these men are roughly six feet tall, and the catwalks on the diesels behind them are parallel to the bank, making them anywhere from 9 to 10 feet high.

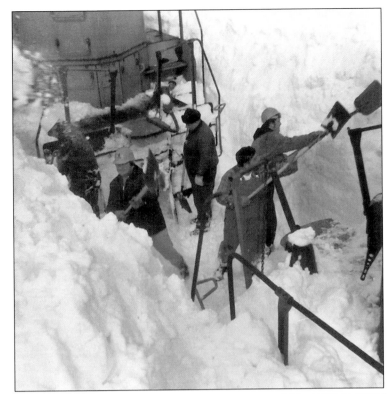

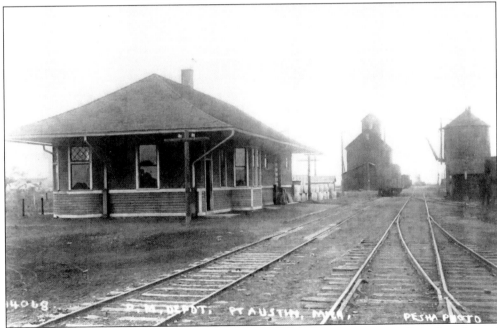

Shown around 1915 is the Pere Marquette Railway's Port Austin depot, originally built as the end of the branch from Bad Axe. An extension from here was constructed in 1895 to connect with the quarries at Grindstone City. It was maintained until 1932, when the railroad abandoned the extension. (Photograph by Louis Pesha.)

The Port Hope station survives, showing little change from its days on the railroad. Now located on private property, it is in remarkably good shape for its age. The station, also privately owned, was built in 1903 when the Pere Marquette Railroad extended its line from Harbor Beach.

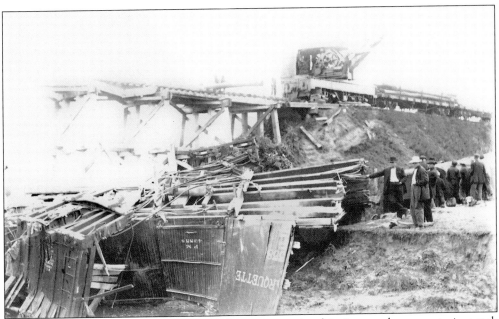

The Pere Marquette wreck derrick is called out once again, this time to clean up a train wreck near Ruth. The local community has come out to the site of a bridge, which seems to have given way under the weight of the train, reducing the wooden boxcars in the train to kindling.

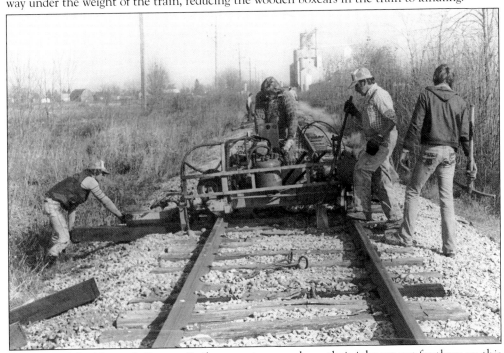

Members of the Huron & Eastern Railway section crew have their jobs cut out for them on this day. Given the condition of the ties they are working on, it does not look like they will be getting to Ruth (seen in the distance) anytime soon. In the far background are Virgil Knopp (left) and Russ Page; in the foreground are, from left to right, Bill Dietchan, Tom Rouston, Charlie Kricher, and Rick Klaski. (Courtesy of Charlie Kricher collection.)

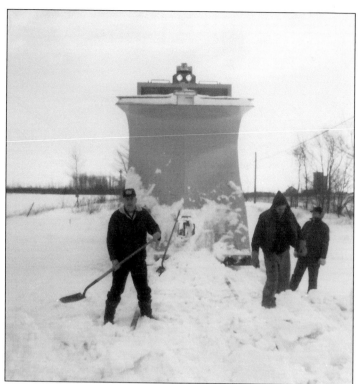

Shown digging out again, the Chesapeake & Ohio Railway crew members excavate a path for the Russell snowplow they had under their care near Ruth. With any hope, they would be back at it soon, plowing their way back home.

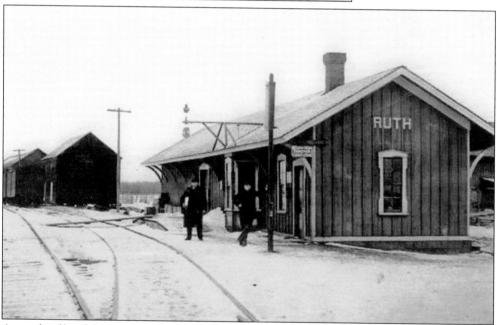

A couple of locals hang out at the station in Ruth around 1910. This small community located in Sheridan Township was founded by John Hunsanger, a native of Hadhomor, Nassau, Germany, who arrived in 1855. So why is the village named Ruth? When the village got a post office in October 1880, it was named after Michael Ruth, who had given property for the railroad depot seen here. (Photograph by Louis Pesha.)

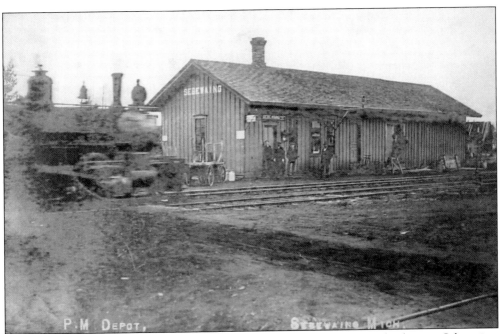

A Pere Marquette steam locomotive is caught in mid-movement as it passes the depot at Sebewaing. Built for predecessor Saginaw, Tuscola & Huron, this depot was a standard design used at Fairgrove, Akron, and other locations. Sebewaing is known as the "Sugar Beet Capital of Michigan" because of the Michigan Sugar slicing mill located within the village and the yearly Michigan Sugar Festival held there. It was also known for Sebewaing Beer, made in the village into the mid-1970s.

This photograph shows a joint excursion train of the Bluewater chapter of the National Railway Historical Society and the Huron & Eastern Railway passing the Sebewaing depot around 1989. The Huron & Eastern purchased the railroad here in the 1990s when CSX put it up for sale.

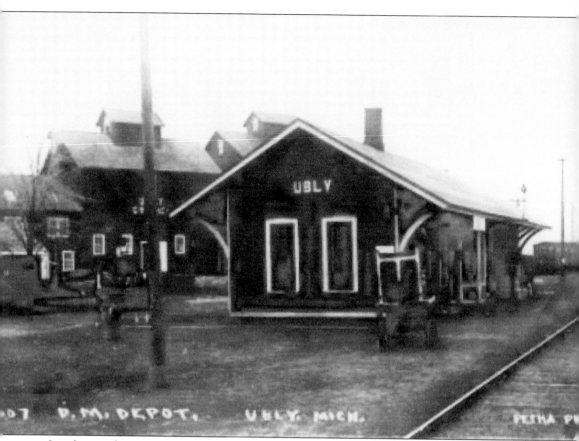

Last but not least is yet another shot by the famous Louis Pesha, this time at Ubly. Once again, the image captures the standard Port Huron & Northwestern board-and-batten depot, many of which survive to the present day. (Photograph by Louis Pesha.)

# Two

# LAPEER COUNTY

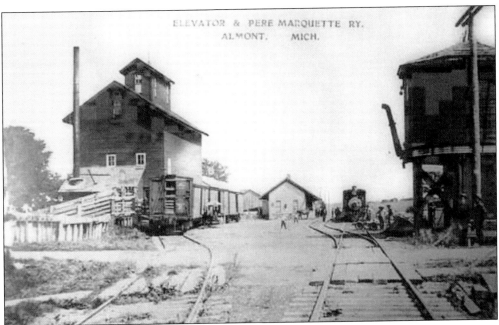

ELEVATOR & PERE MARQUETTE RY.
ALMONT. MICH.

The Port Huron & Northwestern's Almont branch was constructed in 1882. It was meant to tap into the interior of the lower Thumb region to compete with the growing traffic on the nearby Grand Trunk line to Flint. It was built as a narrow gauge and remained this way until it was converted to standard gauge in 1903. Here, the daily train of successor Flint & Pere Marquette is pictured at the end of the line in Almont. (Photograph by Hancock.)

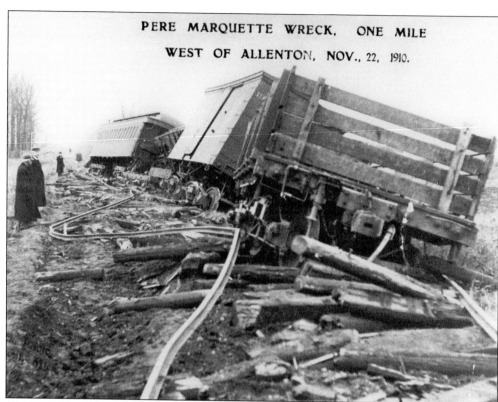

PERE MARQUETTE WRECK. ONE MILE WEST OF ALLENTON, NOV., 22, 1910.

Although they indicate different locations, the two photographs on this page show the same wreck on the Pere Marquette Railway line between Port Huron and Almont. This series of photographs, taken by the photographer Hancock from the Almont area, shows the front end of the train after removal of the locomotive. Although this is soon after the conversion of this branch to standard gauge, the line's overall condition clearly has not improved much from its early construction. (Both photographs by Hancock.)

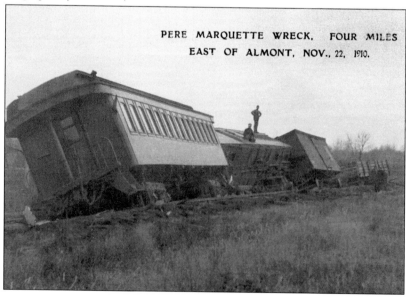

PERE MARQUETTE WRECK, FOUR MILES EAST OF ALMONT, NOV., 22, 1910.

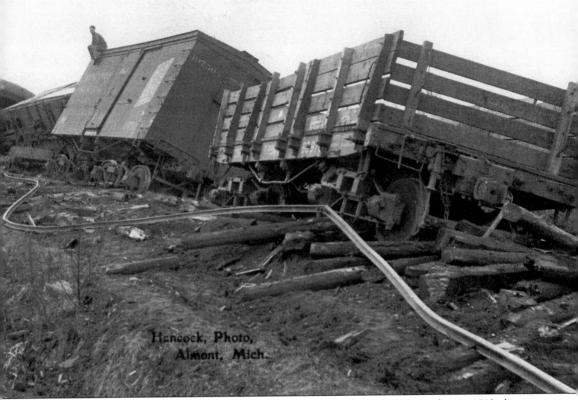

Here is another image of the Pere Marquette Almont wreck by Hancock. Taking place in 1910, this is just a short seven years after the railroad became standard gauged. (Photograph by Hancock.)

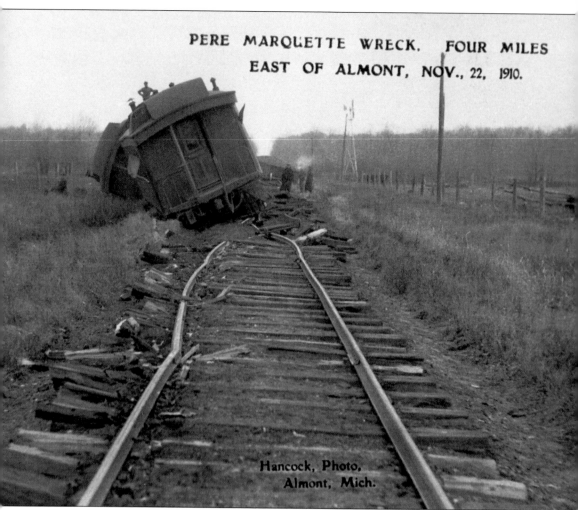

PERE MARQUETTE WRECK. FOUR MILES EAST OF ALMONT, NOV., 22, 1910.

Hancock, Photo,
Almont, Mich.

The lack of maintenance seen here is evident and most likely led to the Pere Marquette Almont wreck. This series of images clearly shows that some locals enjoyed the wreck for its unusual nature. (Photograph by Hancock.)

Pictured is the depot at Clifford around 1920. This small community was located at the crossing of the Pere Marquette's Port Huron–Saginaw line and the Grand Trunk's Pontiac-Caseville line. The original Pere Marquette station was a small affair and is shown here as the extension on the right. When the Pontiac, Oxford & Northern (PO&N) line was completed in the early 1900s, an L-shaped addition complete with bay window was added. This remained in place into the early 1950s, when the agency was eliminated and the whole structure was destroyed.

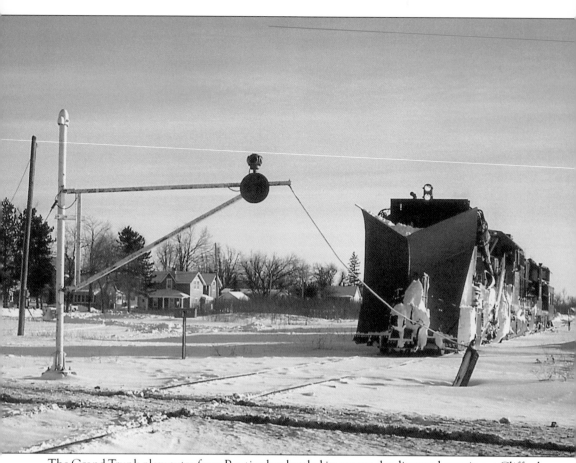

The Grand Trunk plow extra from Pontiac has battled its way to the diamond crossing at Clifford in this 1970s view. The Jordan spreader clearly has run through some high snow drifts given the height of the packed snow on the engines behind it. A simple affair, the "smash board" was always lined against the Grand Trunk here, as it arrived after the PM. It was removed in the mid-1980s. (Photograph by Jeff Mast.)

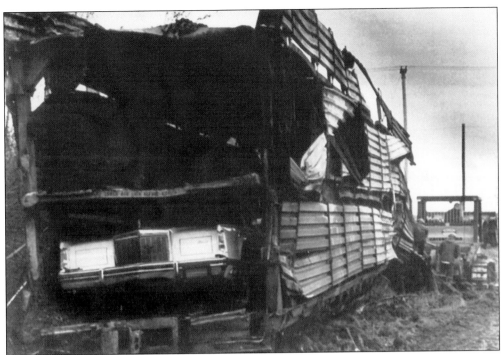

A Lincoln Continental sticks its front end out of an autorack car as the remains of a wreck are cleaned up between Clifford and Silverwood in 1975. This wreck happened when the local Chessie System train ran into a siding.

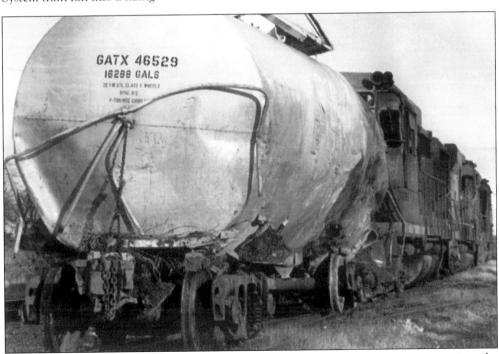

This tank car caring butadiene ignited when the Chessie System train carrying it ran into the siding near Clifford. The fire burned for more than 48 hours before it could be contained.

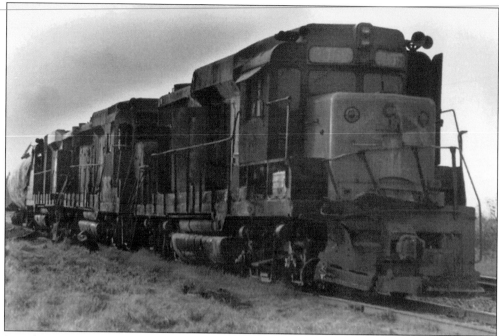

Less than 10 years old when the 1975 wreck at Clifford happened, three Chessie System GP30s were ravaged by the ensuing fire. The ruptured tank car sent out a cloud of poisonous gas at the time it ignited, causing the evacuation of much of the community.

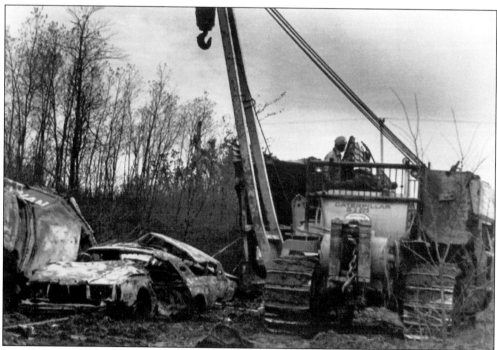

The cleanup of the wreck continues. Eventually, it was found that this wreck was caused by vandalism. The lock for the switch, which had been cut, was found in a nearby field by investigators.

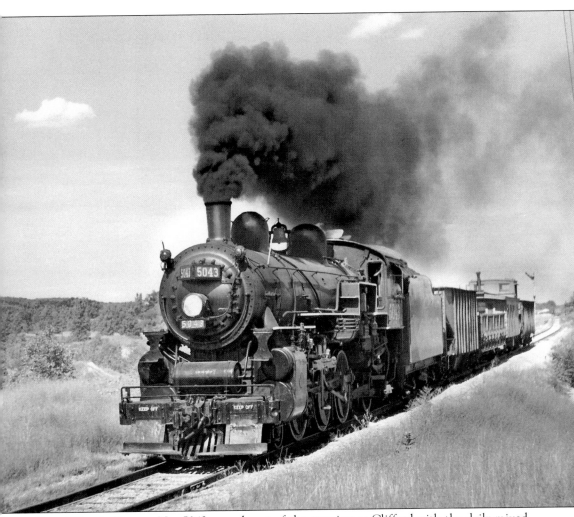

Grand Trunk Western No. 5043 pounds out of the crossing at Clifford with the daily mixed train sometime after the station was removed in the 1950s. The order board denoting its location can be seen in the background. The fireman is pouring in the coal, as the black stack on the engine denotes. This makes sense, as the gradient here would require a bigger head of steam to get ahead.

# Flint & Pere Marquette Railroad Co.

## TELEGRAPHIC TRAIN ORDER No. 9

Form 312.

From _Pt Huron_ _May 19_ 189_9_

| 31 X | For _Marlette_ to _C & E_ of _No 335_ |

No 334 Eng 32 and
No 335 Eng 76 will
meet at Clifford

WST

**CONDUCTOR AND ENGINEMAN MUST EACH HAVE A COPY OF THIS ORDER.**

Time Received _1.06_ M X Given at _1.08 PM_ M

| Conductor | Train | Made | At | Received by |
|---|---|---|---|---|
| Goodridge | 335 Marlette | 108 PM | Smit |
| | | | | |
| | | | | |

This document gives a real window into the railroad operations that were once commonplace in the Thumb. Each day, the Flint & Pere Marquette would send one train from Saginaw (No. 334) and one from Port Huron (No. 335) in either direction. On this particular date in 1899, the Port Huron station is notifying the trains by sending a telegraph order to the Marlette station to meet in Clifford.

46

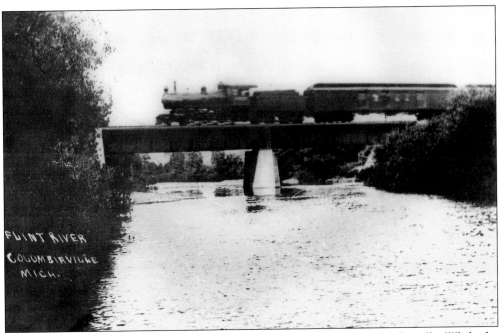

A Michigan Central train powers across the Flint River bridge near Columbiaville. While the Michigan Central may not have had a huge presence in the Thumb, when it did it built fairly permanent structures, such as the one shown here.

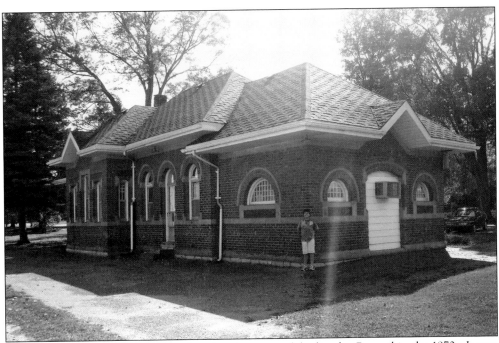

Here is the Columbiaville station after abandonment of the line by Conrail in the 1970s. It now houses the local Rotary chapter.

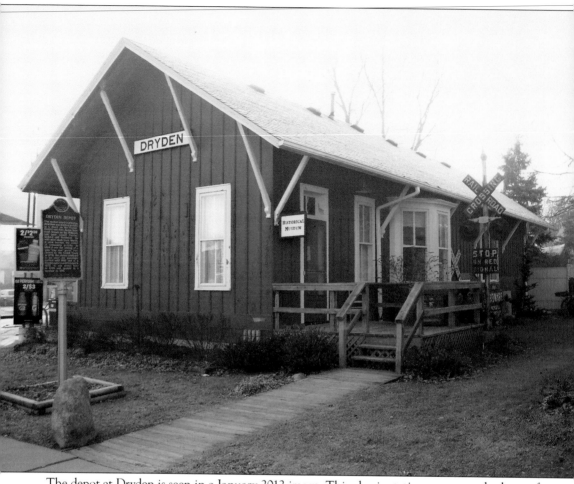

The depot at Dryden is seen in a January 2012 image. This classic station was a standard one of the Pontiac, Oxford & Northern, a GT predecessor. Several variations survive, including the one at Dryden, which has been moved into town.

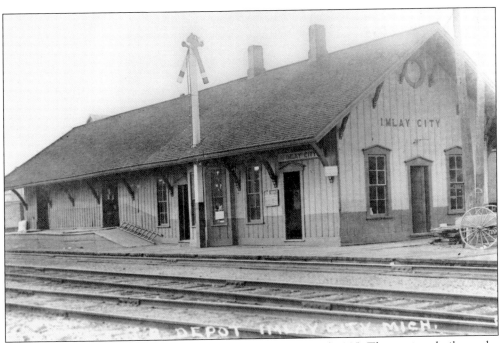

This photograph shows the first station at Imlay City around 1905. The station, built on the Chicago–Port Huron main line, was of typical Chicago & Grand Trunk Railway design. It would not last, however, as it burned to the ground sometime in the 1920s. It was replaced by a brick structure that survives to this day. (Photograph by Louis Pesha.)

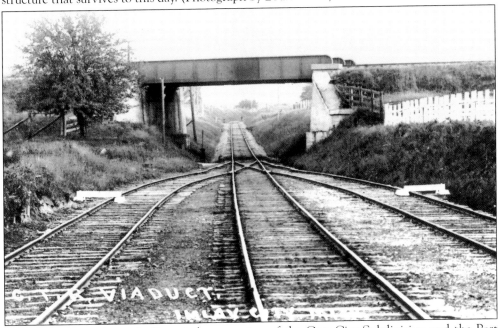

This view shows the main-line viaduct crossing of the Cass City Subdivision and the Port Huron–Chicago main line near Imlay City. A service track just out of the photograph allows a link to the two. The traffic generated via the GT main line necessitated this type of crossing, even in 1910. (Photograph by Louis Pesha.)

# PONTIAC, BAD AXE AND CASEVILLE

| 49 ☐ | Miles | TABLE No. 211 (Central Time) | 52 ☐ |
|---|---|---|---|
| **A.M.** | | | **P.M.** |
| †6.30 | ...... | **Lv Detroit,** ...... (E.T.) **Ar** | †1.50 |
| †5.30 | ...... | **Mich.** (C.T.) ▲⊖ | 12†50 |
| **A.M.** | | | **A.M.** |
| †7.00 | 0 | ⌈ L **Pontiac** 210, 214 ⊙ A ⌉ | 11†30 |
| f7.18 | 5.90 | Eames............ | 11f06 |
| f7.30 | 8.90 | Randall Beach.. | 11f00 |
| 7.50 | 13.60 | Oxford .......... | 10.50 |
| 8.05 | 18.00 | Shoupe.......... | 10f36 |
| 8.20 | 21.00 | Leonard ......... | 10.30 |
| 8.35 | 27.00 | Dryden............ | 10.15 |
| 9.00 | 33.00 | **Imlay City,** 87.... | 10.00 |
| 9.30 | 39.10 | Lum .............. | 9.30 |
| 9.40 | 42.50 | Kings Mill....... | 9.15 |
| 9.55 | 48.50 | North Branch... | 9.00 |
| 10.20 | 54.60 | Clifford.......... | 8.35 |
| 10.40 | 61.60 | Kingston........ | 8.05 |
| 10.55 | 65.40 | Wilmot........... | 7.50 |
| 11.10 | 68.50 | Deford......... | 7.40 |
| 11†45 | 74.40 | ⌊Ar Cass City ....Lv⌋ | †7.25 |
| ☐ | | | ☐ |
| 3@30 | 74.40 | ⌈Lv Cass City Ar⌉ | 8 815 |
| f4.00 | 82.13 | Greenleaf ... | f7.45 |
| f4.10 | 85.67 | Atwater..... | f7.20 |
| f4.20 | 88.67 | McIntyre.... | f7.12 |
| 4@45 | 93.23 | ⌊Ar Bad Axe. Lv⌋ | 8 700 |
| 11†45 | 74.40 | ⌈Lv Cass City Ar⌉ | †7.25 |
| 12.10 | 80.00 | Gagetown .. | 7.00 |
| 12.30 | 85.00 | Owendale ... | 6.40 |
| 12.40 | 87.00 | Linkville .... | f6.30 |
| 1.05 | 91.90 | Pigeon....... | 6.20 |
| †1.30 | 100.00 | Ar **Caseville,** Lv | †6.00 |
| **P.M.** | | **Mich.** | **A.M.** |

According to the schedule for the Cass City Subdivision (including the Bad Axe branch) from about 1925, there were essentially only two trains running on this branch, which became a mixed passenger and freight train from a very early date.

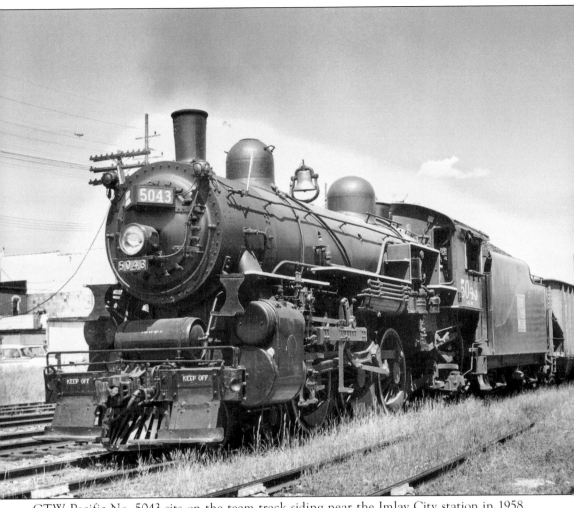

GTW Pacific No. 5043 sits on the team track siding near the Imlay City station in 1958. Seen here near the end of her career, No. 5043 still looks like she could run another 40 years. She and sister No. 5038 held the mixed train assignment on the Cass City Substation almost exclusively until they were eliminated in 1955. Nearly five years later, they could still be found on the freight local. Built in 1912, No. 5043 would survive all but one of her sisters, being scrapped in September 1961.

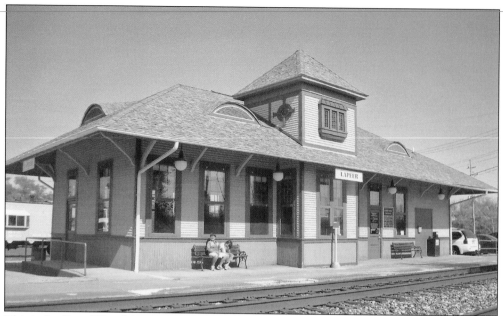

This is the Grand Trunk Lapeer station in 2011. It continues to serve as an Amtrak station nearly 110 years after its construction.

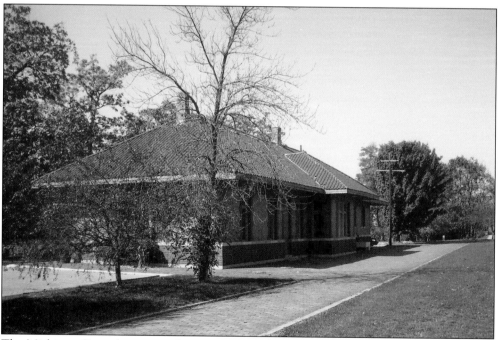

The Michigan Central station at Lapeer is pictured in 2011. Today it is home to an insurance agent. (Author's collection.)

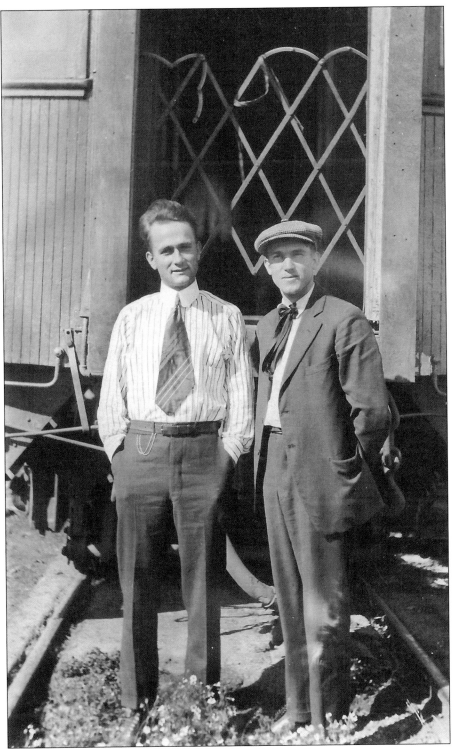

Here, two gentleman take a break at Lapeer around 1930. It is unknown whether they are standing behind a Grand Trunk or New York Central coach.

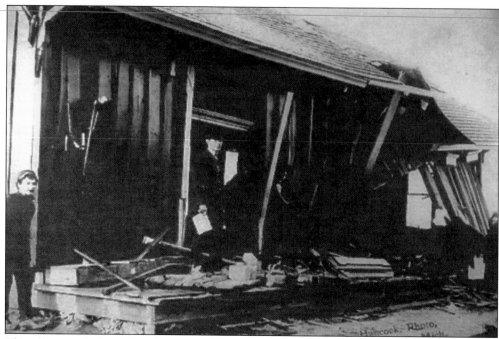

This photograph shows the aftermath of an explosion at the PO&N (later Grand Trunk) depot at Lum in 1909. It could be titled, "A bad day at Lum!" (Photograph by Hancock.)

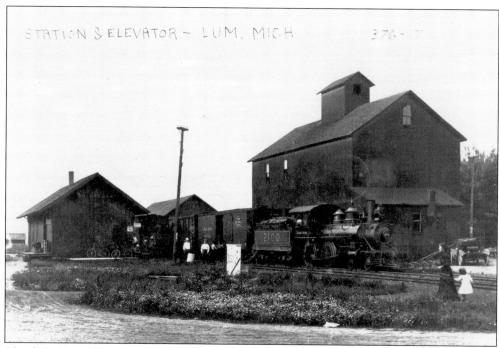

The daily Grand Trunk train passes the repaired depot and elevator at Lum around 1915. Even though it was just a few miles above Imlay City, the train is clearly the one connection to the outside world that Lum has in this view. (Photograph by Hancock.)

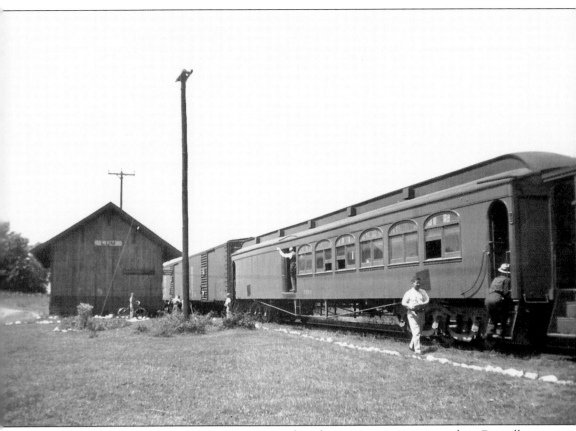

Grand Trunk mixed train No. 49 pauses at Lum to board passengers on its way north to Caseville. Built by Osgood Bradley in the late 1890s, the combination coach in this view survived into the late 1960s. The author was fortunate enough to acquire the stained-glass, arched-top windows seen in this view from a Canadian collector, and they remain some of the most prized pieces of "railroadiana" in his collection. (Photograph by William J. Miller.)

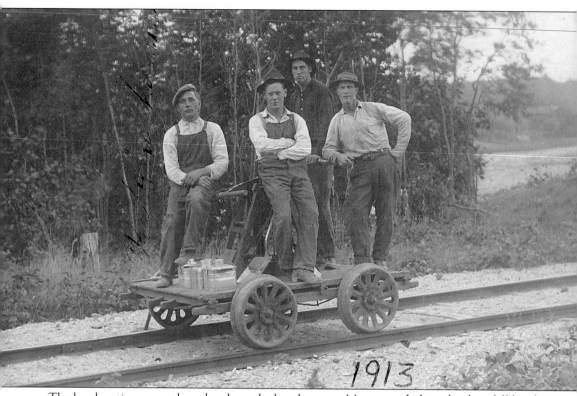

1913

The local section crew takes a break on the handcar near Metamora. Judging by their full lunch buckets, it is still morning in this 1913 view.

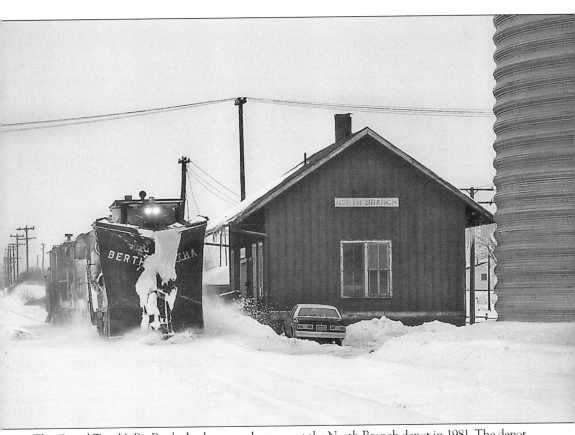

The Grand Trunk's *Big Bertha* Jordan spreader poses at the North Branch depot in 1981. The depot and the line are on borrowed time here, but only the 1970s-era vehicle and the diesel locomotives behind the spreader denote the time period. (Photograph by Jeff Mast.)

## Trains Northward — FLINT and FOSTORIA — Trains Southward

| Long Car Room on Other Tracks | Long Car Room on Siding | 2nd Class 207 Daily Ex.Sun | TIME TABLE No. 11A Sunday, June 13, 1920 STATIONS. | 2nd Class 208 Daily Ex.Sun | Telegraph Stations. | Distance from McGrew. |
|---|---|---|---|---|---|---|
| 10 | | s 3 10 PM | .............. McGREW .............. | s10 45 AM | | ...... |
| 15 | | s 3 25 | 3.71 .............. GENESEE .............. | s10 20 | | 3.71 |
| 11 | | s 3 45 | 2.39 .......... ROGERSVILLE .......... | s 9 50 | | 6.10 |
| 3 | 19 | s 4 00 | 3.83 ........... OTISVILLE ........... | s 9 30 | D | 9.9? |
| 24 | | s 4 20 | 4.40 X........ OTTER LAKE .......... | s 8 20 | D | 14.34 |
| 16 | 22 | 4 40 PM | 5.18 ........ **FOSTORIA** ........ | 8 00 AM | D | 19.51 |
| | | Daily Ex.Sun | | Daily Ex.Sun | | |
| | | 207 | | 208 | | |

Syphon at Fostoria and Otisville.

Nos. 207 and 208 are Mixed trains.

This is a schedule from the 1920s showing the Flint River Division at the line's greatest length. Known as the Huckleberry line because the train moved slow enough for passengers to pick huckleberries while onboard, it remained a vital connection to the outside world for the people of Genesee and Lapeer Counties for many years. Today, a small portion of line remains as the narrow-gauge Huckleberry Railroad.

# *Three*

# St. Clair County

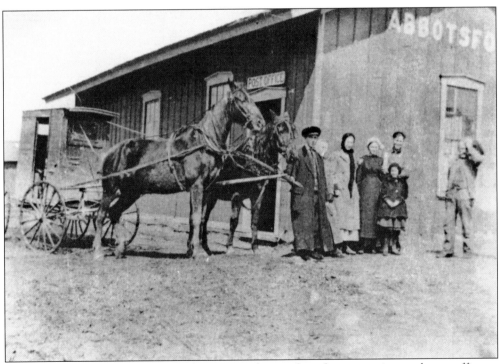

The mail carriage waits for its daily route at the combined train station and post office at Abbotsford around 1900. In an effort to shorten its route from Port Huron to Saginaw, the Flint & Pere Marquette rerouted its tracks through Avoca, Abbotsford, and Wadhams in the mid-1890s, abandoning an early route through Fargo. The new route followed a previous stagecoach route through the area, resulting in new stations at Avoca and Abbotsford. Much of this trackage is now abandoned, but the route survives as the St. Clair County Parks' Wadhams to Avoca Trail. (Courtesy of Port Huron Museum Collection.)

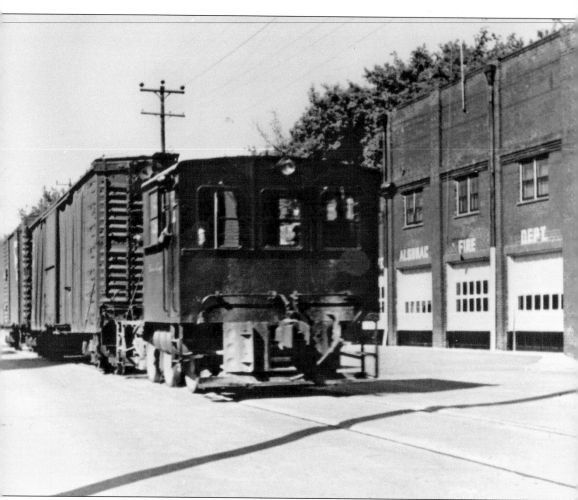

The Chris Craft's Plymouth locomotive moves a pair of boxcars over former Detroit United Railway trackage in Algonac, Michigan. Initially, when the interurban considered abandonment of its line to Mt. Clemens through here, the Handy Brothers Port Huron & Detroit proposed to buy the line, as several customers still required service; however, the Handy Brothers empire collapsed. Wooden pleasure-boat builder Chris Craft was forced to purchase the trackage between Algonac and the connection with the Port Huron & Detroit at Marine City. Officially named the Algonac Transit Company, this wholly owned subsidiary moved cars of wood in and finished runabouts out for the next 25 years until the plant's full conversion to truck service led to the abandonment of the line in the mid-1950s. (Courtesy of Gene Buel collection.)

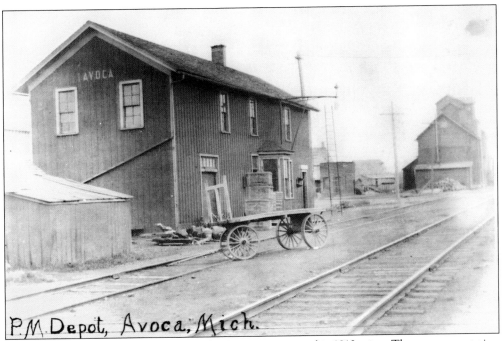

PM. Depot, Avoca, Mich.

It looks like it is a busy day for freight at the Avoca station in this 1910s view. The two-story station seen here was a standard design for remote locations and could be seen at other Pere Marquette communities, such as Bay Port and Fostoria. The second floor provided housing for the station agent and his family where housing was scarce. Although the elevator in the background still stands, the station was removed early on, and the site is now the start and end of the Wadhams to Avoca Trail.

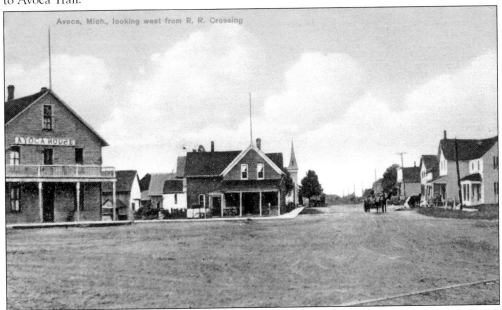

Avoca, Mich., looking west from R. R. Crossing

Almost the whole community of Avoca can be seen in this view. The railroad bisected the small community until 1922, when a fire destroyed much of what is seen here. Although the church in the background still stands, the fledging community growth ended, and very little remains today.

# AVOCA ELEVATOR CO.

## WHOLESALE AND RETAIL

| CEMENT | GRAIN, SEEDS, FEED | COAL |
|---|---|---|
| FERTILIZER | **PHONE 2285** | SALT |

AVOCA, MICH., _1 __ 19___

Sold To _Glen (Nutton)_

Address _____

| QUAN. | DESCRIPTION | PRICE | AMOUNT |
|---|---|---|---|
| | _Farm Egg Mash_ | | |
| | _Pigeon Hen Food_ | 2.00 | |
| | _Shells_ | | |
| | _Tax_ | | |
| | | | 22.46 |

Interest at 6% Will Be Charged on All Past Due Accounts

**CERTIFICATE UNDER AGRICULTURAL PRODUCING EXEMPTION**

The undersigned hereby certifies that all items, except as indicated hereon, are purchased for use or consumption in connection with the production of Horticultural or Agricultural products as a business enterprise and agrees to reimburse the seller the Sales Tax if used or consumed otherwise.

UARCO INC. - WATSEKA, ILL.

No. A14034

Signed _____

Illegal use of this certificate subjects persons to the penalties of the Sales Tax Act.

Like many communities in the Thumb, Avoca had an elevator to serve the farmers of the community. While it allowed the farmers to deliver their goods to market, it also served as a location to get some of their basic supplies. Unlike many communities, Avoca's elevator still stands and serves its customers nearly 120 years after it opened.

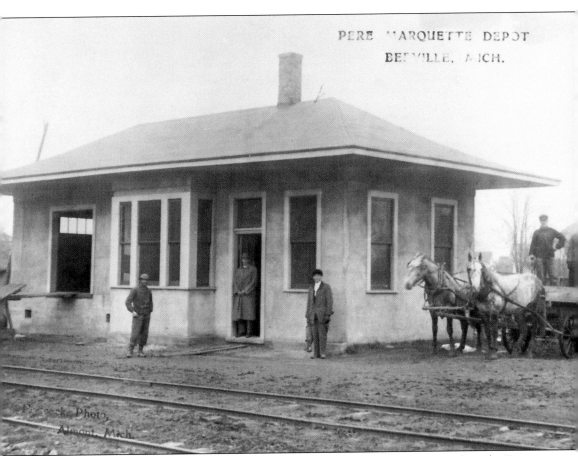

PERE MARQUETTE DEPOT
BERVILLE, MICH.

Workers take a break from the construction of the depot at Berville in 1903. When the Pere Marquette standard gauged the line in 1903, the town petitioned the railroad for the larger depot seen here. This station was standard to several other Pere Marquette structures with one exception: it used concrete in its construction. To the author's knowledge, it was the only such PM depot to use cement for its exterior in this region. (Photograph by Hancock.)

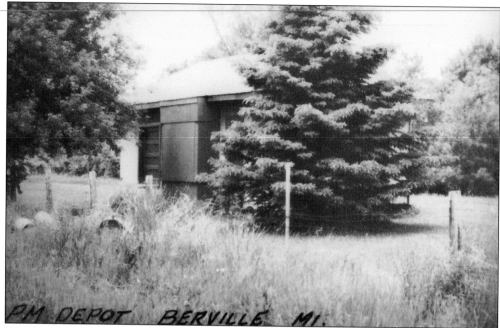

This later picture shows the same building after the railroad had been abandoned and the station agency closed. In the early 1990s, it was relocated to Allenton and is now a small museum display.

It is a lazy summer day in the small town of Blaine. Although the right-of-way is fairly clean, the condition of the roadbed and ties in this 1920s view leaves a little to be desired. The depot was closed in 1960 by the Chesapeake & Ohio and bought by a family who moved it to St. Clair. It remains there to this day as part of a house along the St. Clair River.

It is 1971, and the days are numbered for both the Blaine General Store and the Chesapeake & Ohio Railway's tracks in the foreground. In less than a year, the tracks will be gone, the general store will be relocated to Wildcat Road, and this building removed.

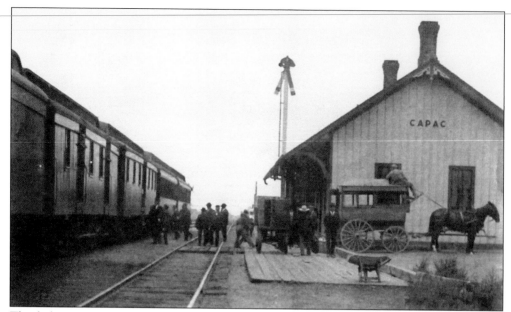

The daily train to Port Huron unloads and picks up passengers at Capac, while the stagecoach to the local hotel waits for patrons to climb aboard. This station survived for a few more years before a fire in the early 1910s leveled it. Built in 1914, the successor station survives to this today and has been moved to a new location east of town on M-21.

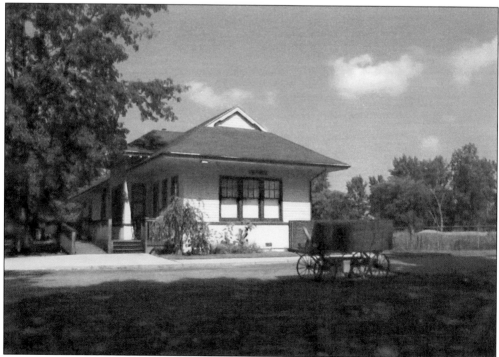

This view shows the second Capac Grand Trunk station after it was relocated just east of town. Nicely restored, it is now the community's museum.

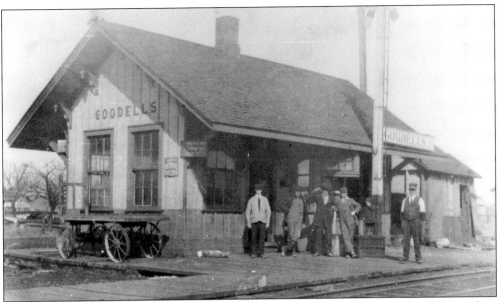

Locals huddle around the ticket window at Goodells. A small community, Goodells was best known as the home of the St. Clair County Poor Farm and Medical Center. The station seen here was used until the early 1950s, when it was sold and moved to a farm at the intersection of Imlay City and Quaine Roads where it stands today.

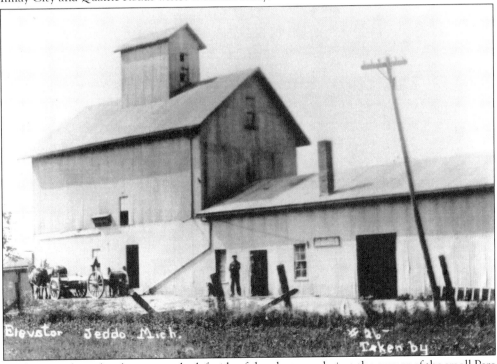

Sticking out from the elevator on the left side of the photograph, just the corner of the small Pere Marquette station can be seen in this view. No other known photographs of this station seem to exist, as it met an untimely end along with much of the elevator when it was destroyed by a tornado in May 1953. The agency was abandoned soon after.

## ALMONT DIVISION.

| | | Distance from Port Huron. | STATIONS. | Trains East. | | | |
|---|---|---|---|---|---|---|---|
| | | | | FIRST-CLASS. | | | |
| | | | | 392 Mail. | 394 Mixed. | | |
| | | | | Daily Ex. Sun. | Daily Ex. Sun. | | |
| | | | | A. M. | P. M. | | |
| | | 3.8 | C. & G. T. JUNCTION ...................Arrive | 7 21 | 3 25 | | |
| | | 8.4 | Kimball ................................... | f 7 09 | f 3 05 | | |
| | | 10.6 | Burns ................................... | f 7 02 | f 2 55 | | |
| | | 14.0 | Wales ................................... | f 6 55 | f 2 43 | | |
| | | 15.7 | Lambs ................................... | f 6 50 | f 2 37 | | |
| W | D | 19.7 | Memphis ................................... | s 6 39 | s 2 20 | | |
| | D | 23.4 | Doyle ................................... | f 6 30 | f 2 01 | | |
| | | 25.6 | Berville ................................... | s 6 23 | s 1 51 | | |
| | | 29.0 | Smiths ................................... | f 6 15 | f 1 39 | | |
| W X C | D | 31.7 | Hopkins Road ................................... | f 6 07 | f 1 27 | | |
| | | 33.9 | ALMONT ...................Depart | 6 00 | 1 15 | | |
| | | | | A. M. | P. M. | | |
| | | | | Daily Ex. Sun. | Daily Ex. Sun. | | |
| | | | | Mail. 392 | Mixed. 394 | | |

Trains going toward Port Huron have right to road against trains of the same or inferior class moving in the opposite direction as per rule 84.

This schedule shows the route and stations of the Almont branch of the Flint & Pere Marquette, later the Pere Marquette Railway. The majority of this branch was located within the confines of St. Clair County, and its epicenter was the small town of Lambs, shown at milepost 15.7. This branch did not survive World War II and was abandoned in 1942.

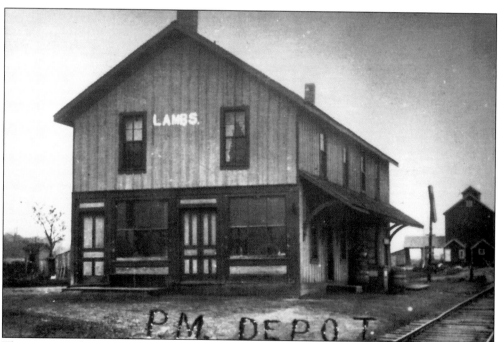

The two-story depot at Lambs is pictured around 1910. Much like Avoca and Bay Port, this tiny community had little available housing, and so the railroad provided it for the station agent and his family, as well as a space for the local post office. (Photograph by Louis Pesha.)

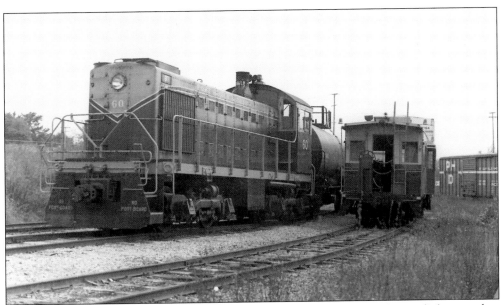

Port Huron & Detroit Railroad ALCO S2 diesel No. 60 meets one of the road's bay-window cabooses while switching cars at a petro chemical plant at Marysville around 1980. Owned by the Duffy family, this small road made its living on switching at the local industries between Port Huron and Marine City. (Courtesy of George Duffy Jr. collection.)

The first Chessie System train to operate over the PH&D after its sale moves past the Morton Salt plant on October 31, 1984. The closure of the Morton Salt plant and terms demanded by the family of Jim Duffy led to the forced sale of the railroad by the other half owners, the George Y. Duffy Sr. family, ending nearly 60 years of service to local industry.

This bucolic scene shows the area around the depot at Memphis around 1915. Located near the border of Macomb and St. Clair Counties on the Pere Marquette's Port Huron to Almont branch, the community of Memphis was considered part of both. (Photograph by Louis Pesha.)

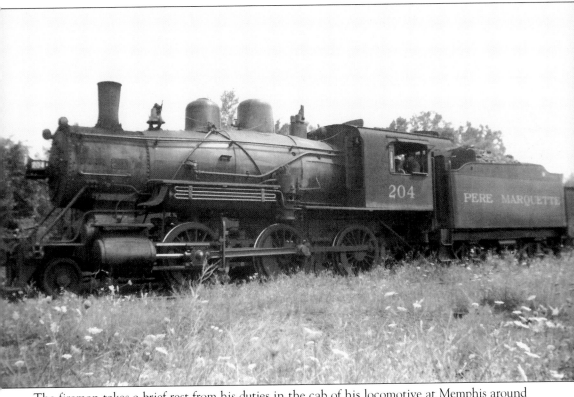

The fireman takes a brief rest from his duties in the cab of his locomotive at Memphis around 1938. Pere Marquette Class M No. 204 was built by the Brooks Locomotive Works in 1904 and was retired in 1944. (Photograph by William J. Miller.)

# SARNIA LINE.

### New Summer Route to the West!

—VIA—

## GRAND TRUNK RAILWAY,

### OF CANADA.

**1863.**        **1863.**

---

### New Lines of Powerful First Class Steamers from

## PORT SARNIA & PORT HURON

—TO—

### GREEN BAY, MILWAUKEE,

# CHICAGO,

### SAULT STE. MARIE, BRUCE MINES, ONTONAGON,

#### And other Ports on

### LAKES HURON, MICHIGAN & SUPERIOR.

The Steamers of the above Lines leave Sarnia and Port Huron on arrival of the Grand Trunk Trains, in the following order:

*Chicago and Milwaukee Line,*

Leave SARNIA every TUESDAY, THURSDAY and SATURDAY Evening.

*GREEN BAY LINE,*

Leave PORT HURON every SATURDAY Evening.

*LAKE SUPERIOR LINE,*

Leave PORT HURON every TUESDAY, WEDNESDAY, THURSDAY and SATURDAY Evenings. Passengers from the Eastern States, for all points on Lake Superior, save TWENTY-FOUR HOURS time by taking the Grand Trunk Railway to Port Huron.

**For SAGINAW & LAKE HURON SHORE PORTS,**

Leave PORT HURON every TUESDAY, THURSDAY and SATURDAY Evening.

### RATES OF FARE

From Portland, Danville and Yarmouth Junctions.

*MEALS AND BERTHS INCLUDED IN FIRST CLASS PASSAGE.*

| | 1st Class. | 2d Class | | 1st Class. | 2d Class |
|---|---|---|---|---|---|
| Manitowoc, | 21 40 | 13 25 | New River, | 19 50 | 12 50 |
| Sheboygan, | 21 40 | 13 25 | Port Hope, | 19 50 | 12 50 |
| Port Washington, | 21 40 | 13 25 | Bay City, | 19 50 | 12 50 |
| Milwaukee, | 21 40 | 13 25 | East Saginaw, | 19 50 | 12 50 |
| Racine, | 21 40 | 13 25 | Saginaw City, | 19 50 | 12 50 |
| Kenosha, | 21 40 | 13 25 | Sault Ste. Marie, | 25 00 | 14 00 |
| Waukegan, | 21 40 | 13 25 | Marquette, | 30 00 | 16 00 |
| Chicago, | 21 40 | 13 25 | Portage Lake, | 33 00 | 18 00 |
| Green Bay, | 21 40 | 13 25 | Copper Harbor, | 34 00 | 19 00 |
| Salinac, | 18 50 | 11 50 | Eagle River, | 34 00 | 19 00 |
| Forrestville, | 18 50 | 11 50 | Ontonagon, | 35 00 | 19 00 |
| Forrester, | 18 50 | 11 50 | La Pointe, | 38 00 | 21 00 |
| Port Austin, | 19 50 | 12 50 | Superior City, | 40 00 | 22 00 |
| Willow Creek, | 19 50 | 12 50 | | | |

Through Tickets can be obtained at the Grand Trunk Agencies BOSTON, BANGOR and OGDENSBURGH, and at all principal Ticket Offices in New England, and at

## 22 West Market Square, Bangor.

**C. J. BRYDGES,** Managing Director, Montreal.

**S. SHACKELL,** General Eastern Agent, Boston.

### W. FLOWERS, East. Agent, Bangor.

Traveller Job Printing House, 5 Congress Street, Boston.

This 1863 broadside from the Grand Trunk is one of the earliest pieces of advertising for Port Huron's rail connections. The Grand Trunk's line from Port Huron to Detroit is but four years old, and so most connections from there or Sarnia have to be made by ship, as seen in this document.

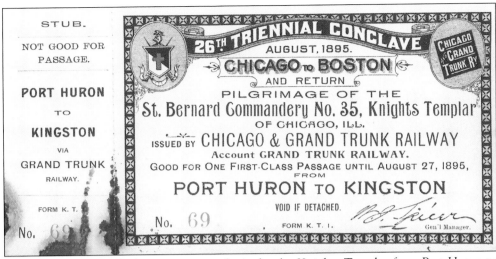

This ticket from 1895 advertises a special trip for the Knights Templar from Port Huron to Kingston, Ontario. Special tickets and rates were not uncommon for special groups, and fraternal organizations in particular used rail excursions as a way to ensure members could cheaply attend national meetings.

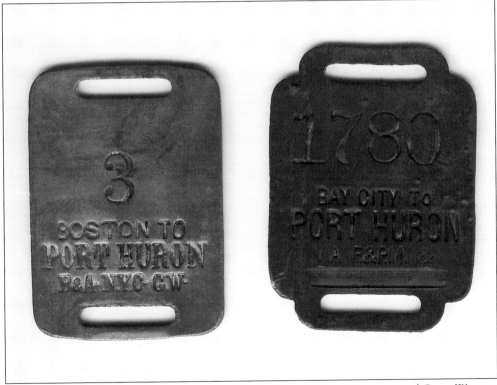

These two brass baggage tags were once used by the Flint & Pere Marquette and Great Western to delineate where a particular set of baggage was to go. These tags were attached to a leather strap with an identical larger tag until they were fastened to a set of baggage before the small tag was then given to the bag's owner. At the conclusion of his journey, the owner returned the tag to show the bag was his. These tags date from the 1890s and are extremely rare today.

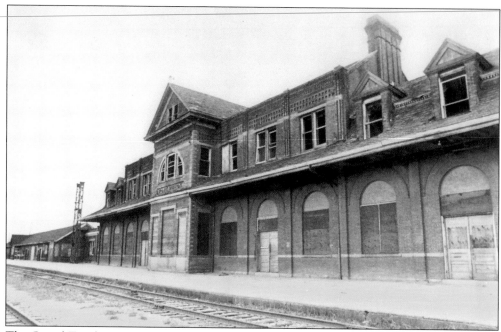

The Grand Trunk "Tunnel" station at Port Huron is shown just before its destruction in 1974. The US Customs Office and Railway Express Agency building can be seen just beyond it to the left. Built in 1892, this ornate station saw nearly 45 passenger trains a day from three different railroads and one interurban.

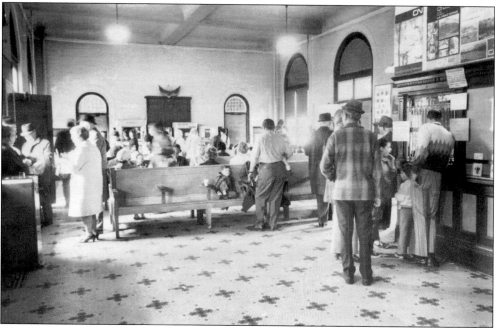

This view of the interior of the Port Huron "Tunnel" depot is from about 1968. The station's destruction was one of the darker moments in rail preservation, and although stated as being for a yard expansion, it never materialized. The outcry over the destruction of this station is one of the reasons that Durand Union station was eventually saved.

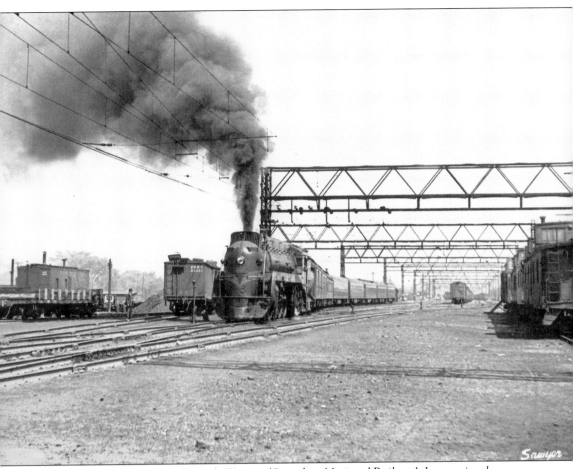

In this image, the joint Grand Trunk Western/Canadian National Railway's *International* storms out from the Port Huron Tunnel station under the electrical catenary towers of the St. Clair Tunnel Company. Often found powered by one of the Grand Trunk's 6400 Class U-4-b's as seen here, it was not uncommon for this train to hit 90 to 100 miles per hour by the time it reached Emmett, just a few miles away. (Photograph by Russell Sawyer.)

One of Grand Trunk's 0-8-0 switchers sorts passenger cars in the Port Huron yard around 1955. These hefty switchers had long lives, and even after being sent to scrap they were used by the scrapper, Northwestern Steel and Wire, as power into the early 1980s. (Photograph by Bob Gray.)

This view shows the Port Huron's Pere Marquette depot at the foot of Court Street around 1925. The station was built in 1914 to replace the two-story Port Huron & Northwestern station, which burned in a spectacular fire the year before. It still survives and is now the headquarters of Boatnerd as part of the Acheson Ventures site.

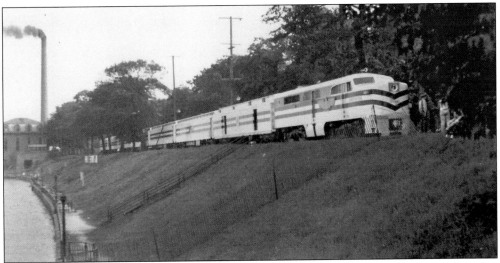

The American Freedom Train comes to Port Huron around 1948. This train was put together after World War II to carry priceless documents to the people of the country, including the Declaration of Independence. The track this train is sitting on, which belonged to the Chesapeake & Ohio, was removed from Pine Grove Park in 1971. (Courtesy of Port Huron Museum Collection.)

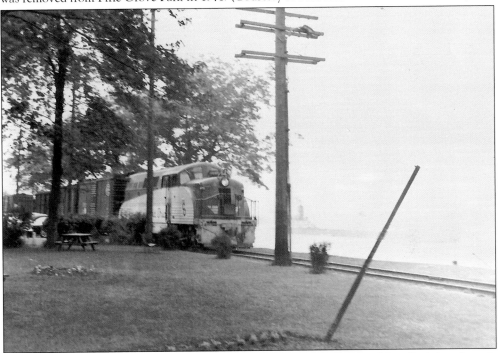

A Chesapeake & Ohio Railway BL2 diesel locomotive brings the daily local from Bad Axe through Pine Grove Park in Port Huron. Introduced in 1948, BL2s were developed by the Electro-Motive Division of General Motors as a lighter-weight diesel locomotive for branch line use. The C&O purchased them for use in the Thumb region, where the track weighed as little as 65 pounds per yard. As such, these locomotives were used almost exclusively by the C&O as the sole motive power on the trains for nearly 15 years, not being replaced until the early 1960s. (Courtesy of Port Huron Museum Collection.)

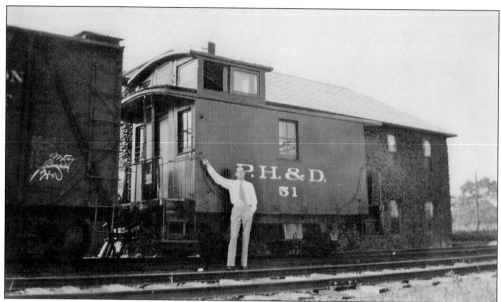

President George Y. Duffy Sr. proudly stands next to "bobber" caboose No. 51 at the Port Huron & Detroit corporate offices in Port Huron around 1946. These cabooses were used in smaller industrial and logging railroads where narrow spaces were an issue. By this late date, they were extremely rare. (Courtesy of George Y. Duffy Jr. collection.)

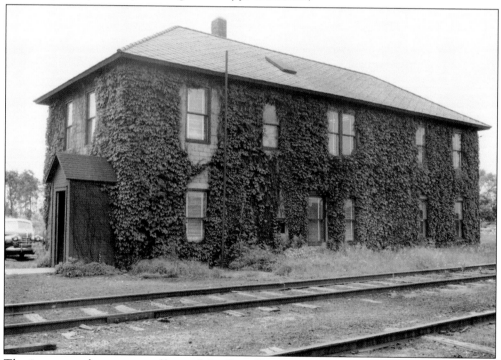

The ivy-covered corporate offices of the Port Huron & Detroit are pictured in 1947. This building, which was added onto after World War II, still stands and is currently owned and being restored by the Port Huron & Detroit Railroad Historical Society. (Courtesy of Port Huron Museum Collection.)

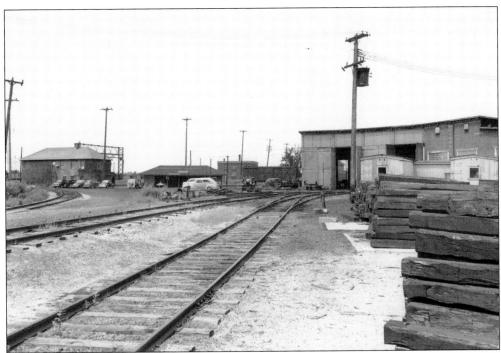

The Port Huron & Detroit Railroad's Port Huron yard is pictured around 1947. Although small, the facilities here held everything a short-line railroad needed, from a roundhouse for locomotive repair to storage for track maintenance supplies. Surprisingly, nearly 65 years later, much of this scene could be re-created, although the roundhouse is in danger of being demolished because of its dilapidated state. (Courtesy of Port Huron Museum Collection.)

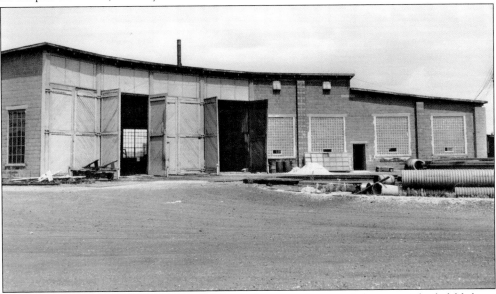

This is a closer shot of the PH&D roundhouse shown at the top of the page. The bifold doors shown here were later replaced with more modern steel roll-up doors. The roundhouse is still owned by CSX Transportation, and the PH&D Historical Society is trying to raise funds to purchase it and save it from the wrecking ball. (Courtesy of Port Huron Museum Collection.)

It is a cold February day in the Pere Marquette's Port Huron yard in 1926, and the engineer on 2-8-0 No. 918 has just opened the cylinder cocks to prepare to move his locomotive. Built by Brooks Locomotive Works in 1911, this locomotive lasted until the PM's 1947 merger with the C&O, when it was scrapped. (Photograph by Bob Gray, courtesy of Port Huron Museum Collection.)

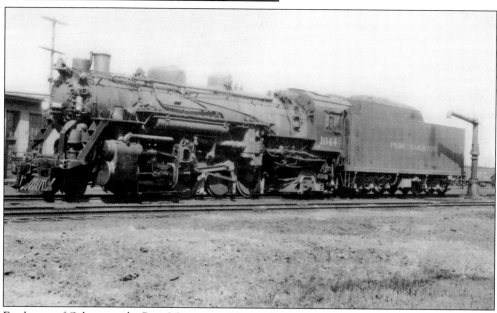

Fresh out of Schenectady, Pere Marquette Class Mk-2 2-8-0 No. 1044 takes water at the Port Huron Sixteenth Street roundhouse in April 1928. This locomotive was built by ALCO in 1927, was renumbered to C&O No. 1063 in 1947, and was scrapped in 1952. (Photograph by Bob Gray, courtesy of Port Huron Museum Collection.)

The Detroit Bay City & Western (DBC&W) pile driver/wrecker slowly lays in the third set of pilings for the railroad's new bridge over the Black River at Ruby. Better known as the "Handy Brothers railroad," the DBC&W began construction from Bay City in the early 1910s but did not reach Port Huron until 1915, thanks in large part to the chasm being bridged here. (Courtesy of George Y. Duffy Jr. collection.)

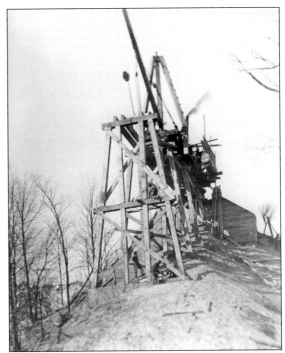

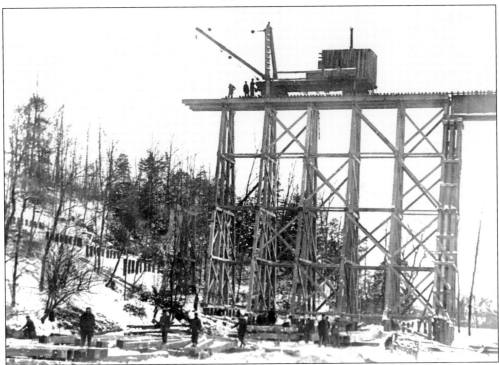

The DBC&W bridge at Ruby begins to take shape as the pile driver reaches ever closer to the other bank of the Black River in this c. 1914 photograph. The next bracing beams, preconstructed on the ground below, will soon be in place to complete the structure. (Courtesy of George Y. Duffy Jr. collection.)

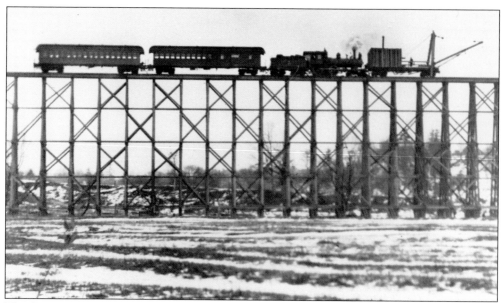

The first train across the new DBC&W Railway bridge at Ruby appears here in the winter of 1914. (Courtesy of George Y. Duffy Jr. collection.)

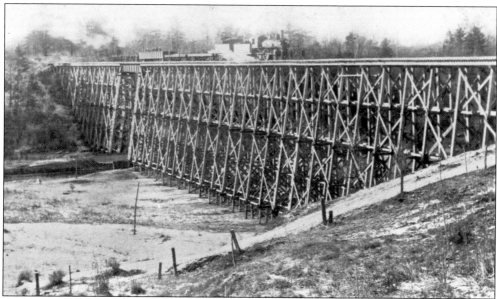

This extremely rare shot shows a freight train crossing the DBC&W bridge at Ruby in the late 1910s. Of the few photographs that exist of the structure, this one shows the grandeur and the feat of engineering it took to build this massive bridge. Of note is the fact that nearly 90 percent of the structure is treated white pine; only two steel girders and the rails, tie plates, and the spikes themselves were of iron or steel in this massive bridge. Sadly, however, it was short lived. The Handy Brothers empire collapsed in the mid-1920s, and the successor railroad, the Detroit, Caro & Sandusky, quickly decided to abandon the bridge, moving its southern terminus to Roseburg in the late 1920s. The bridge was disassembled piece by piece to be used in countless other local construction projects in the late 1920s and early 1930s. Only the original footings and pilings remain today. (Courtesy of George Y. Duffy Jr. collection.)

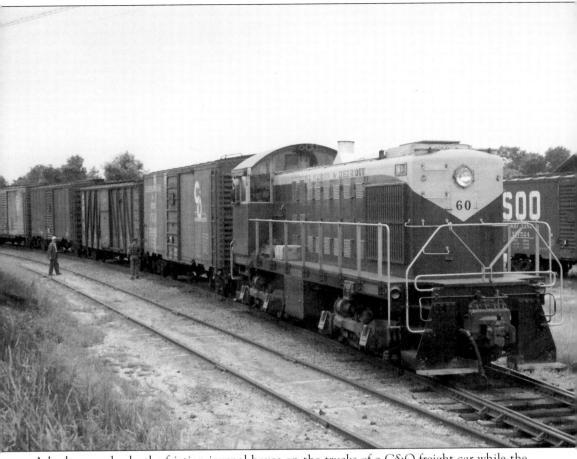

A brakeman checks the friction journal boxes on the trucks of a C&O freight car while the engineer of Port Huron & Detroit Railroad diesel electric No. 60 looks on at St. Clair. Built by ALCO as one of its S2 models, the No. 60 remained with the railroad until 1984, when it was sold by CSX Transportation, which purchased the line. This is a good chance to see the changes brought to freight cars after World War II. Note the steel C&O car's height in comparison to the wood-outside-braced car behind it, most likely constructed in the 1910s.

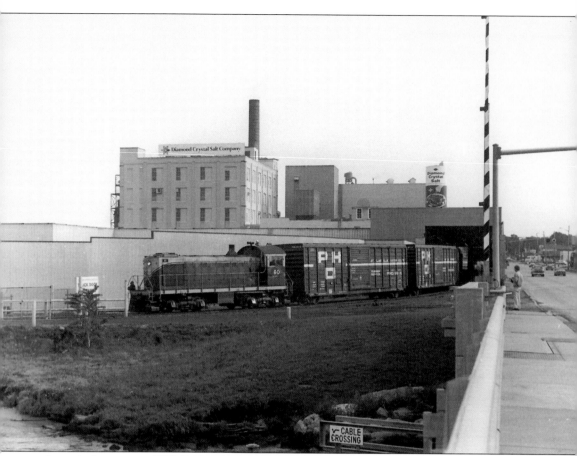

Later in her career, PH&D No. 60 switches at the Diamond Crystal Salt plant in St. Clair. (Courtesy of George Y. Duffy Jr. collection.)

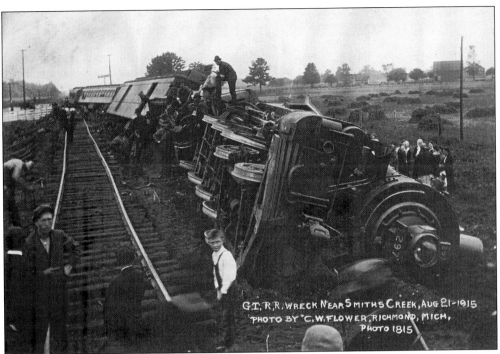

The aftermath of a Grand Trunk wreck at Smiths Creek is pictured here on August 21, 1915. How times have changed; a crowd would not be allowed to get this close to an accident today, let alone a child being allowed to play near a hot locomotive. Engine No. 297 would be repaired and go on to serve many more years. (Photograph by C.W. Flower.)

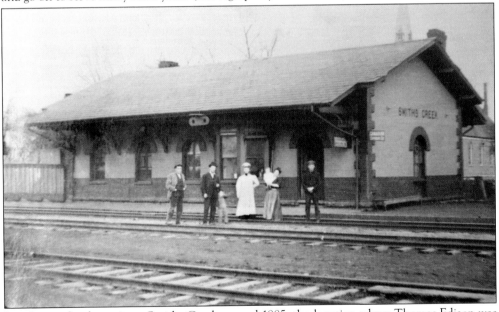

Locals wait for the train at Smiths Creek around 1885; the location where Thomas Edison was thrown off the train in 1863. Henry Ford purchased this station in the 1920s and had it moved to Greenfield Village where it can be seen there today. Its replacement, paid for by Ford, now resides on Armada Ridge Road near Richmond.

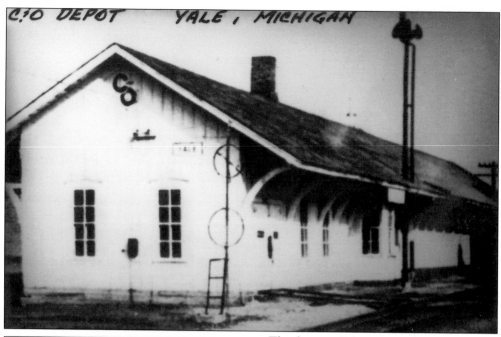

C&O DEPOT    YALE , MICHIGAN

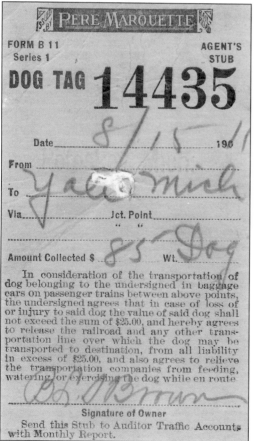

PERE MARQUETTE

FORM B 11                              AGENT'S
Series 1                                  STUB

DOG TAG 14435

Date___8/15___196

From_____

To____Yale, Mich_____

Via_____Jct. Point_____
          " "

Amount Collected $ __85__  Wt.__Dog__

In consideration of the transportation of
dog belonging to the undersigned in baggage
cars on passenger trains between above points,
the undersigned agrees that in case of loss of
or injury to said dog the value of said dog shall
not exceed the sum of $25.00, and hereby agrees
to release the railroad and any other trans-
portation line over which the dog may be
transported to destination, from all liability
in excess of $25.00, and also agrees to relieve
the transportation companies from feeding,
watering or exercising the dog while en route

_____B. L. Brown_____
Signature of Owner
Send this Stub to Auditor Traffic Accounts
with Monthly Report.

The depot at Yale is shown here around 1970. Built for the Port Huron & Northwestern in 1880, this depot was one of the first outlying communities to be connected with Port Huron when the PH&NW was built. A typical station for the road, it was nearly identical to Croswell, Harbor Beach, Minden City, and Ruth. Sadly, this station did not make it much past its 100th birthday, as it was destroyed by a derailment in 1980.

At one time, nearly everything went by rail. In this case, a dog was shipped to Yale for the hefty sum of 85¢—not a small price in 1911.

# *Four*

# SANILAC COUNTY

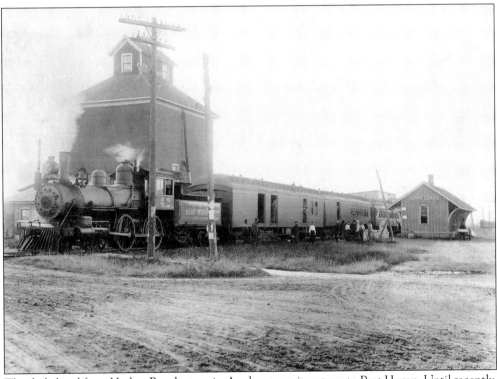

The daily local from Harbor Beach stops in Applegate on its return to Port Huron. Until recently, much of the scene could be replicated, even though the PM depot here was removed early on and replaced with a converted boxcar as a station. Sadly, after standing nearly 125 years as the tallest structure in this part of Sanilac County, the elevator was torn down in March 2009. The locomotive, built by Manchester Locomotive Works for PM predecessor Chicago & West Michigan in 1889, survived until 1923.

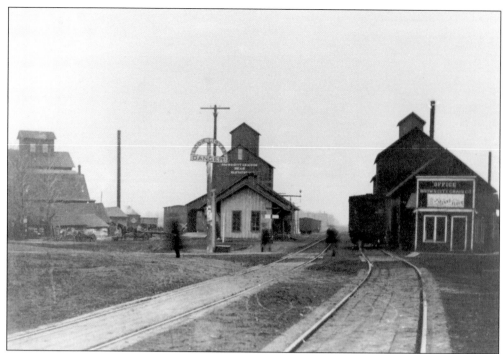

The railroad is fairly new to Brown City in this 1880s view, and it shows. The station is so new that it has yet to have a name painted on its end, and the smell of the fresh-cut lumber of the crossing timbers can almost be detected.

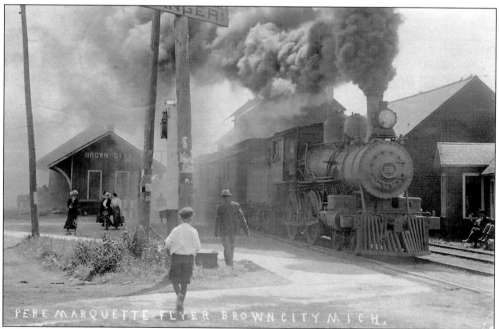

The fireman of No. 28 pours on the coal as the Pere Marquette's daily train powers out of the Brown City station around 1910. Engine No. 28 was built for PM predecessor Chicago & West Michigan in the 1870s and was gone by 1925.

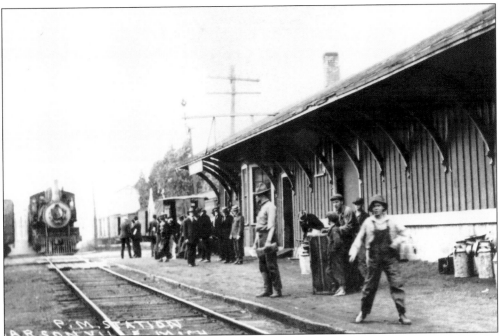

The Pere Marquette train arrives from Bad Axe in Carsonville around 1918. While it can be tough to tell the exact dates of photographs, this one has a great clue with the World War I–era Doughboy soldier standing next to the tracks.

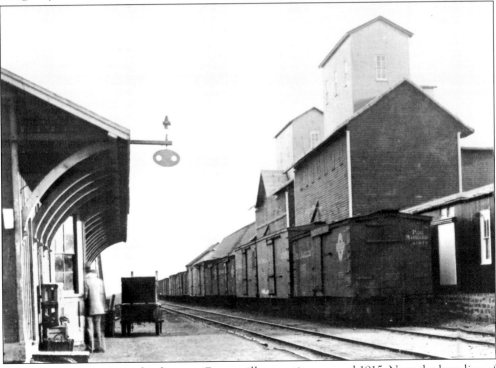

A lone passenger waits at the depot at Carsonville sometime around 1915. Note the long line of cars at the elevator, most likely loading grain.

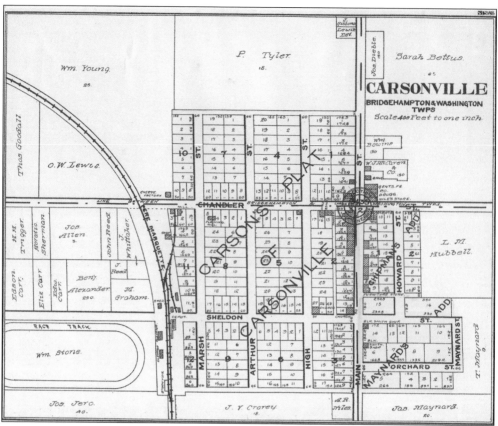

An early-1900s plat map of the village of Carsonville shows the extreme curve the railroad takes to get out of town. Just beyond the Thomas Goodall property is the interchange known as Poland, where the branch to Sandusky splits off the main to Palms and points north.

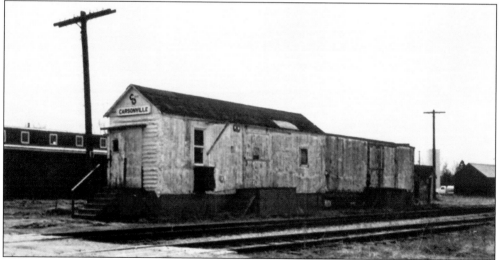

Here is the final incarnation of the Carsonville depot around 1970. The original depot burned at some point and was replaced by the two former Pere Marquette wooden boxcars seen here. (Photograph by John C. Knecht II.)

90

M. 2006. 500 bks. R.

# Pere Marquette Railroad Company.

## ORIGINAL STATION BAGGAGE WAY-BILL.

Aug 28 190___ Station _____

| DESCRIPTION OF CHECKS | | CHECK NUMBERS | DESCRIPTION OF BAGGAGE |
|---|---|---|---|
| of Local, Joint, Special and Card Checks | DESTINATION | | |
| | Croswell | | |
| | | | |
| | | 20 | |
| | | 21 | |
| | Carsonville | 55 89 | |
| | | 90 | |
| | Pt Huron | 838 | |

ge, Supplies, etc., received as above described.

_____ T. B. M.    Train No. _____

aggage, Registered Packages, etc., checked or forwarded from stations must be way-billed in duplicate
al to be kept for reference, and the duplicate given to Train Baggageman.

H. F. MOELLER, GEN. PASS. AGENT.

This shows the typical daily baggage sent on the Pere Marquette from its interchange with Grand Trunk at the "Tunnel" depot in Port Huron. Note the bags going to Carsonville and Croswell, showing their importance to the line.

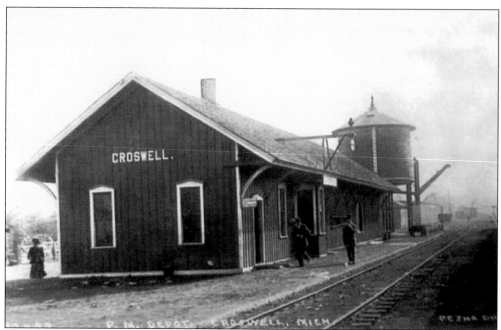

This early view of the Croswell depot was taken around 1910. The depot remained largely unchanged until sometime in the 1950s, when the bay window and waiting-room portion were removed. It was officially the last remaining station agency in the Thumb, closing in 1985 when CSX sold the railroad to Huron & Eastern. (Photograph by Louis Pesha.)

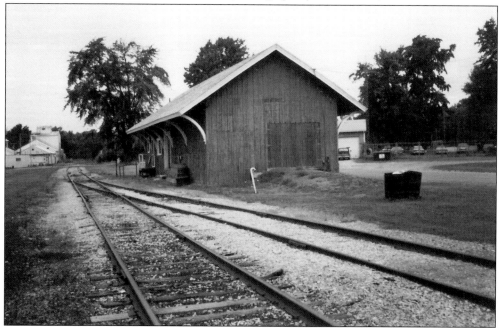

This is the Croswell station as it looks today. The last station agent, Dick Webb, was something of a local legend who was known for his musical abilities; he could often be found playing stringed instruments on the stoop out front. Dick sadly passed away in 2009, but the author was fortunate enough to record his memories for posterity in 1995.

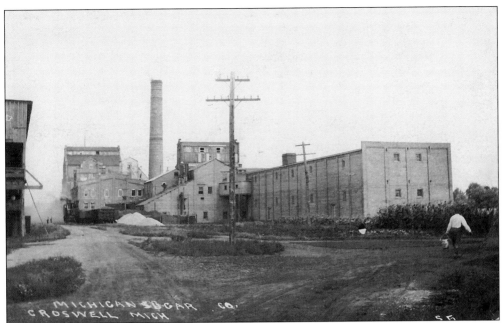

Perhaps readers will recognize the Michigan Sugar Mill at Croswell, pictured here around 1915. Still in use today, Croswell and Sebewaing remain the primary sugar-beet processing plants in the Thumb. Note the small locomotive moving the typical wooden sugar-beet gondolas around the plant and the worker carrying his lunch pail to the job. (Photograph by Louis Pesha.)

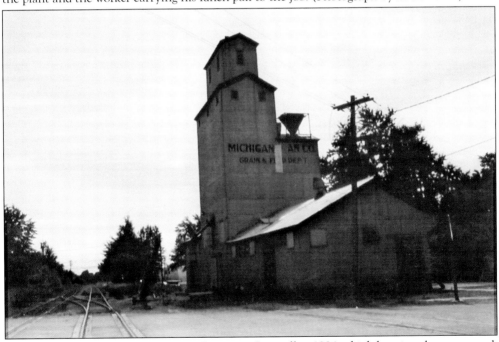

This image shows the Michigan Bean elevator at Croswell in 1994, which has since been removed. The photograph is important for two reasons: one, the last remnant of the original rail laid by the Port Huron & Northwestern lies in the siding here; two, the track to Port Huron now ends just past this spot.

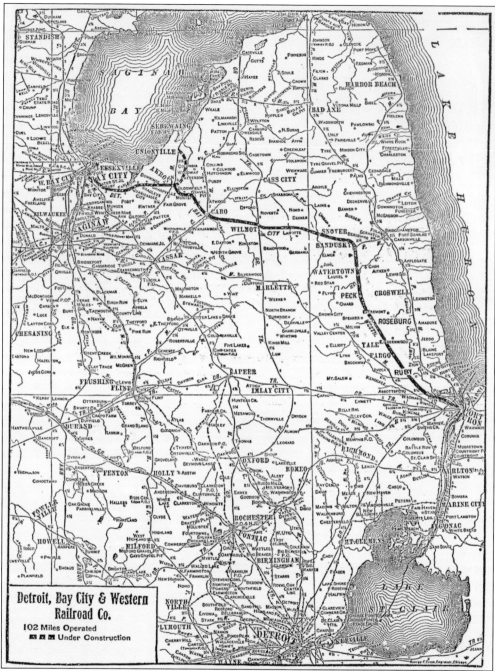

A system map of the Detroit, Bay City & Western at its height in 1918 boasts all 102 miles. By 1953, every stretch of the line—with the exception of a small section in Caro shown on this map between Port Huron and Bay City—would be gone.

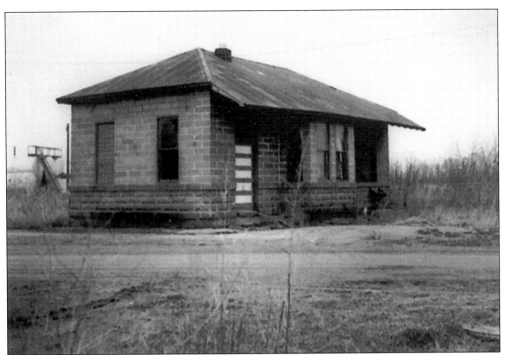

The small former DBC&W/DC&S station at Decker is shown here around 1950. The roof has clearly been cut back, but the standard DBC&W concrete block construction leaves no doubt about its heritage. (Photograph by Bob Gray, courtesy of George Y. Duffy Jr. collection.)

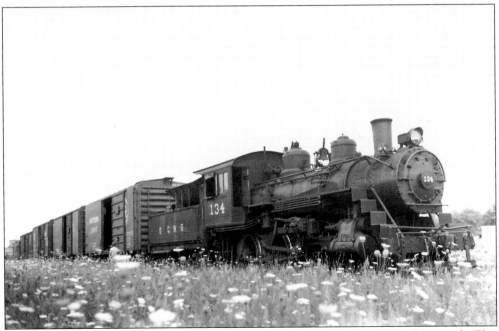

DC&S No. 134 struggles through the wildflowers at Decker in this late-1940s photograph. This gives a great sense of the DC&S maintenance-of-way procedures; in short, there were none. (Photograph by William J. Miller.)

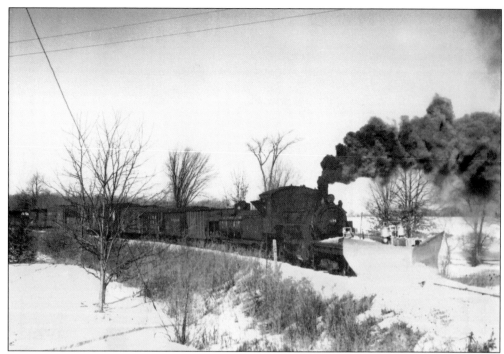

The same No. 134 as on the previous page uses the unique DC&S homemade snowplow to push her way through Hemans in the early 1940s.

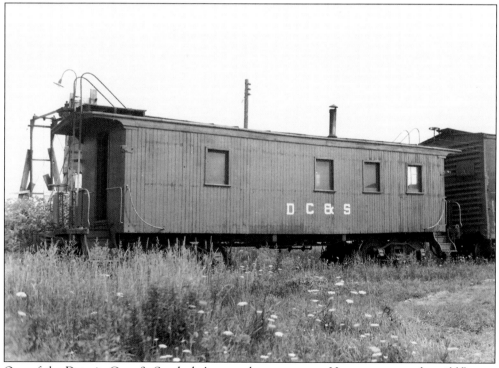

One of the Detroit, Caro & Sandusky's two cabooses rests at Hemans among the wildflowers around 1951. (Photograph by Bob Gray.)

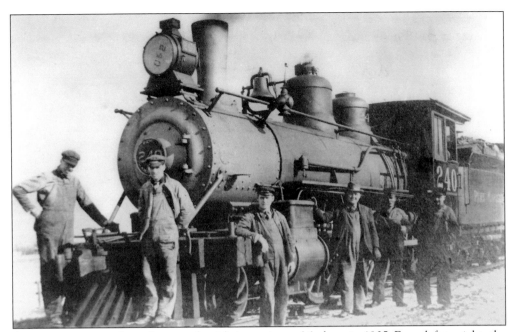

A train crew pauses for a photograph with its engine at Marlette in 1905. From left to right, the men include brakeman Joseph Brownell, William Budd, H.L. Schade, conductor Dan Morris, fireman Jason Lynch, and engineer Robert Steiner. Their trusty steed, 2-6-0 No. 240, was built in 1889 and scrapped in 1920.

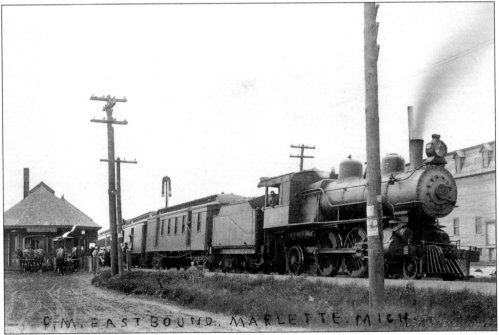

Atlantic No. 392 heads a three-car train at Marlette around 1905. These 4-4-2's were built for speed and known for their ability to get up and go from a dead stop. Sadly, the loss of traffic brought about by the automobile and the Great Depression sent them to the scrapper, this one meeting its maker in 1929.

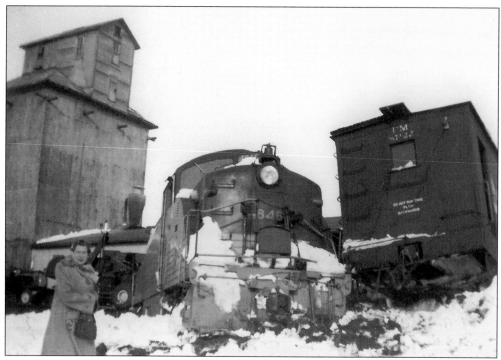

Lucy Gray stands near the BL2 No. 1846 and its jackknifed snowplow SP-22 at McGregor on March 2, 1954. The crewmen on this plow train included track supervisor Jack Moe (operated the plow), Paul Falko (section man from Bad Axe), ? Cash (the engineer), and ? Knox (the conductor). (Photograph by Bob Gray.)

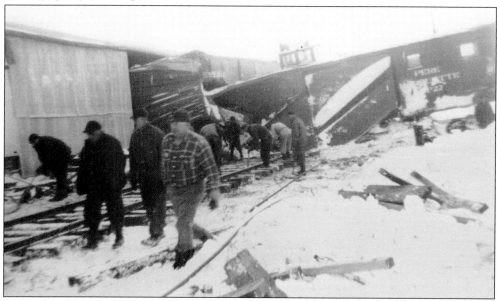

The maintenance-of-way crew surveys the scene of carnage on March 2, 1954. C&O snowplow SP-22, still lettered and painted for predecessor Pere Marquette, has jackknifed into a 40-foot boxcar in the siding, ripping it open like a tin can. The men definitely have their work cut out for them. (Photograph by Jack Moe, courtesy of Phil Shuster collection.)

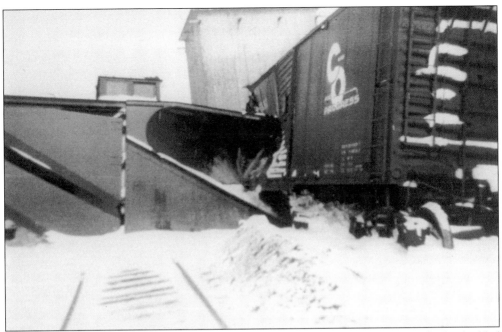

This is another shot of the 1954 wreck at McGregor, showing just how far the plow had imbedded itself in the boxcar. In addition, the force of the impact knocked the car off its tracks. (Photograph by Jack Moe, courtesy of Phil Shuster collection.)

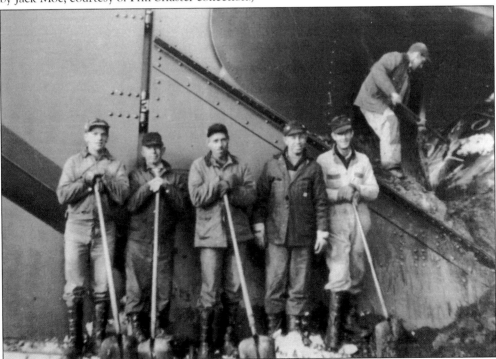

The cleanup crew at McGregor is pictured on March 2, 1954; most of the men were from Carsonville. Sadly, only two names are known: Robert Hall (fourth from the right) and Pete Kendall (standing on the plow). (Photograph by Jack Moe, courtesy of Phil Shuster collection.)

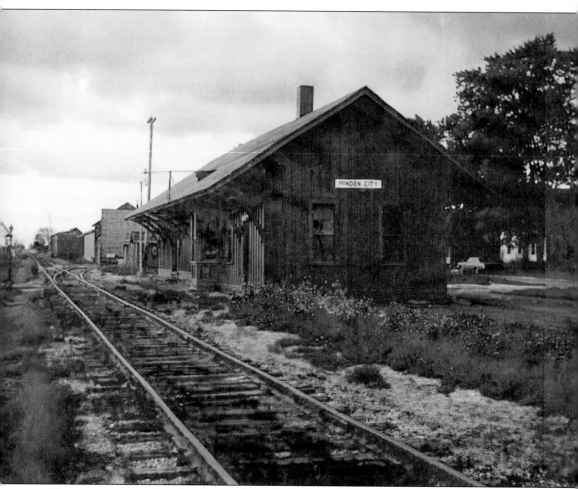

The same station at Minden City is shown here around 1974. Note the flag-style high switch stand on the left, which was unique to the Pere Marquette lines in Michigan. (Photograph by Charles Whipp.)

This timetable shows the Sand Beach Division of the Pere Marquette, which at that time began at Palms and ended at what is now Harbor Beach. This line would be extended to Port Hope in 1903.

## SAND BEACH DIVISION.

| | | | TRAINS NORTH.<br>STATIONS. | FIRST-CLASS. | | | THIRD-CLASS. | |
|---|---|---|---|---|---|---|---|---|
| | | | | 381<br>Mixed.<br>Daily<br>Ex. Sun. | 383<br>Mail.<br>Daily<br>Ex. Sun. | | 387<br>Local.<br>Daily<br>Ex. Sun. | |
| | 39 | | PALMS..................Depart | P. M.<br>12 31 | P. M.<br>6 38 | ........ | A. M.<br>8 15 | ........ |
| S W C Y | 26 | 4.1 | Minden City | s 12 41 | s 6 46 | ........ | s 8 30 | ........ |
| | 10 | 3.6 | Ruth | f 12 50 | f 6 55 | ........ | s 9 43 | ........ |
| | 6 | 4.8 | Helena | f 1 03 | f 7 05 | ........ | f 8 56 | ........ |
| W C X | 85 | 5.8 | SAND BEACH ..............Arrive | 1 18<br>P. M.<br>Daily<br>Ex. Sun.<br>Mixed.<br>381 | 7 20<br>P. M.<br>Daily<br>Ex. Sun.<br>Mail.<br>383 | ........ | 9 15<br>A. M.<br>Daily<br>Ex. Sun.<br>Local.<br>387 | ........ |

| | | TRAINS SOUTH.<br>STATIONS. | FIRST-CLASS. | | | THIRD-CLASS. | |
|---|---|---|---|---|---|---|---|
| | | | 382<br>Mixed.<br>Daily<br>Ex. Sun. | 384<br>Mail.<br>Daily<br>Ex. Sun. | | 386<br>Local.<br>Daily<br>Ex. Sun. | |
| D | | PALMS ..................Arrive | A. M.<br>7 50 | P. M.<br>3 55 | ........ | A. M.<br>11 00 | ........ |
| D | 4.1 | Minden City | s 7 39 | s 3 44 | ........ | s 10 41 | ........ |
| | 7.8 | Ruth | f 7 30 | f 3 35 | ........ | s 10 33 | ........ |
| | 12.6 | Helena | f 7 15 | f 3 23 | ........ | f 10 16 | ........ |
| D | 18.4 | SAND BEACH ..............Depart | 7 00<br>A. M.<br>Daily<br>Ex. Sun.<br>Mixed.<br>382 | 3 08<br>P. M.<br>Daily<br>Ex. Sun.<br>Mail.<br>384 | ........ | 10 00<br>A. M.<br>Daily<br>Ex. Sun.<br>Local.<br>386 | ........ |

Trains going toward Palms have absolute right to road against trains of the same or inferior class moving in the opposite direction.

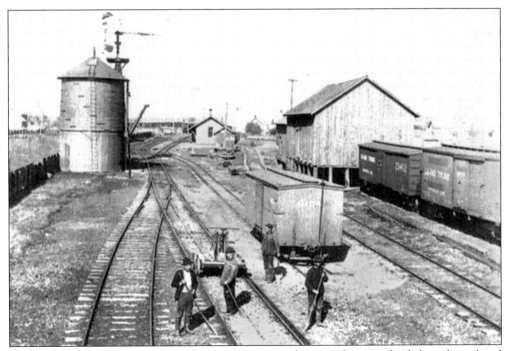

Men work on standard gauging the line at Palms around 1893. Palms was the fork in the railroad for trains going to either Bad Axe or Harbor Beach. Note the smaller boxcar in the foreground.

## HARBOR BEACH BRANCH

| Northward | | | | Southward | |
|---|---|---|---|---|---|
| **THIRD CLASS** | | | **FOURTH CLASS** | | |
| **1109** | | | **1110** | | Miles from Palms |
| Daily Ex. Sun. | STATIONS | | Daily Ex. Sun. | | |
| P. M. | | | P. M. | | |
| 3.15 | .....PALMS...... | | A 7.30 | | ...... |
| 3.45 | ....Minden City.... | | 7.00 | | 4.2 |
| ..... | .....Ruth..... | | ...... | | 7.7 |
| A 5.00 | . HARBOR BEACH . | | 6.00 | | 18.3 |
| ..... | .....Port Hope..... | | ...... | | 25.7 |
| P. M. | | | P. M. | | |

Time of all scheduled trains at Mershon applies at the west switch of siding.

Time of all scheduled trains at Ludington Yard applies at the East switch.

*Time shown in Italics is for information only.*

* Indicates location of General Order boards and Standard Clocks.

This timetable from 1956 was used by the Chesapeake & Ohio. Some of the smaller station stops, like Helena, have been removed because the agencies there closed.

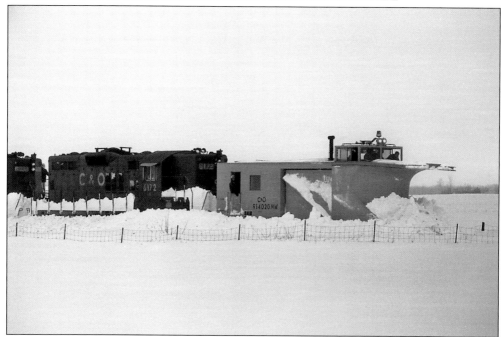

The Chesapeake & Ohio's Russell snowplow clears the line at Palms around 1978. Note how high the snow is on the running boards of the diesel trailing the unit—this is big-snow country. (Photograph by Jeff Mast.)

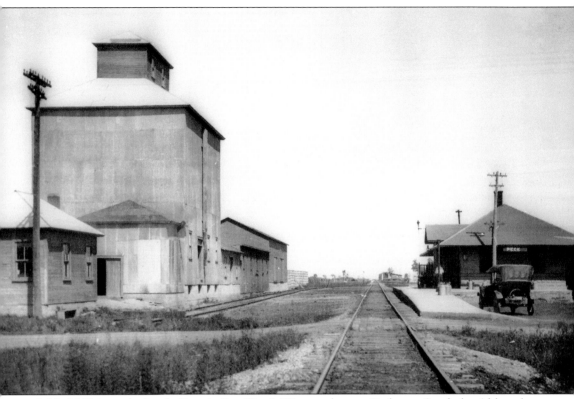

A Model T sits at the lonely Detroit, Bay City & Western depot at Peck near Sandusky. Although just a stop on the way to Port Huron in this c. 1918 view, it was the end of the line for successor Detroit, Caro & Sandusky by 1948. By 1953, even the DC&S would be gone, and all that remains now is the elevator shown on the left.

## SANDUSKY BRANCH

| Northward | | | Southward | | |
|---|---|---|---|---|---|
| **THIRD CLASS** | | | **FOURTH CLASS** | | |
| **911** | | | **912** | | Miles from Poland |
| Daily Ex. Sun. | STATIONS | | Daily Ex. Sun. | | |
| A. M. | | | P. M. | | |
| 10.20 | ...... Poland ....... | | A 12.15 | | ...... |
| A 11.10 | ....SANDUSKY..... | | 11.45 | | 7.1 |
| A. M. | | | A. M. | | |

This is a Chesapeake & Ohio–era timetable for the branch to Sandusky from Poland just north of Carsonville. Although not a long branch, it once fed the important connection with the Detroit, Caro & Sandusky at Sandusky.

It is a cold winter day in the 1970s on the north leg of the wye at Poland. The view is looking back from the cab of EMD GP9 diesel of the C&O toward an A900-series caboose of Pere Marquette heritage. Sandusky is roughly seven miles directly to the right of the caboose.

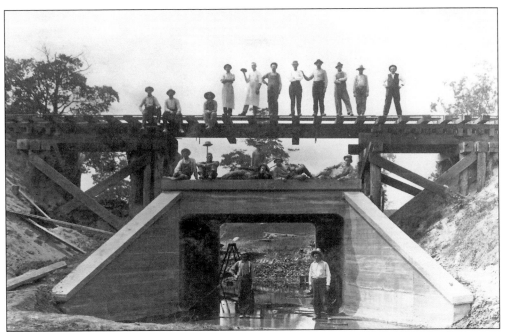

A construction crew hangs out on the makeshift wooden trestle while waiting for the cement to dry on the new culvert four miles in from Poland on the Sandusky branch. Of interest is the second man sitting on the culvert and what he has done with his bowler. Though the branch was abandoned in the early 1990s, this culvert still stands in a farmer's field, now used to connect one pasture with another.

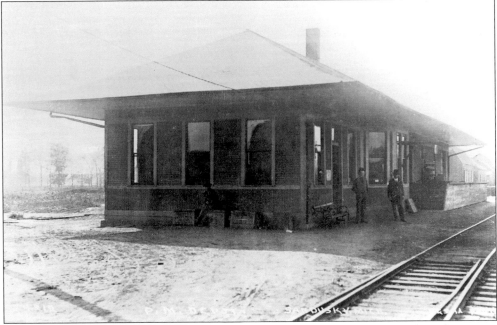

This photograph catches the locals at the Pere Marquette station in Sandusky. The station was constructed before the Detroit, Bay City & Western reached the village. (Photograph by Louis Pesha.)

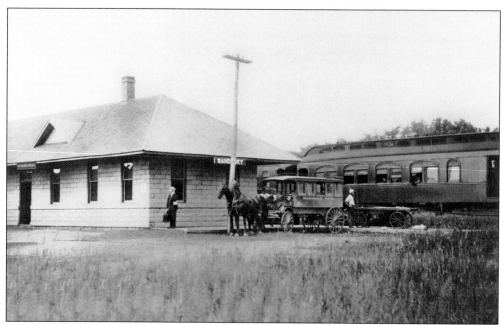

The coach from the hotel waits to pick up passengers from the daily DBC&W train from Saginaw to Port Huron. The DBC&W's classic concrete block construction was ahead of its time and gave this community its second train station.

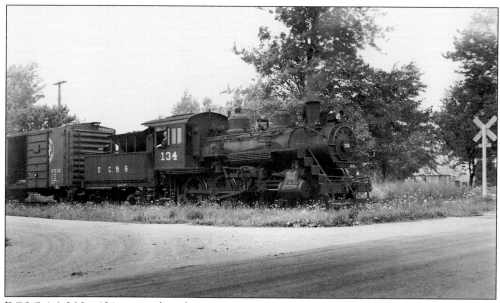

DC&S 4-6-0 No. 134 approaches the crossing at Snover around 1950. Although the tracks are covered with weeds, the roads and cross bucks remained well groomed in the later days of the railroad. (Photograph by Bob Gray.)

# *Five*

# TUSCOLA COUNTY

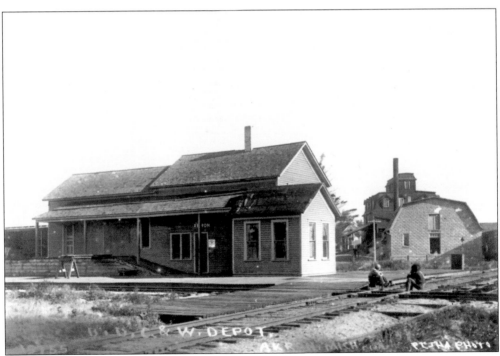

A couple of kids play at the crossing of the Detroit, Bay City & Western and the Pere Marquette at Akron around 1910. This station and the crossing were fairly short lived, surviving to just 1925. (Photograph by Louis Pesha.)

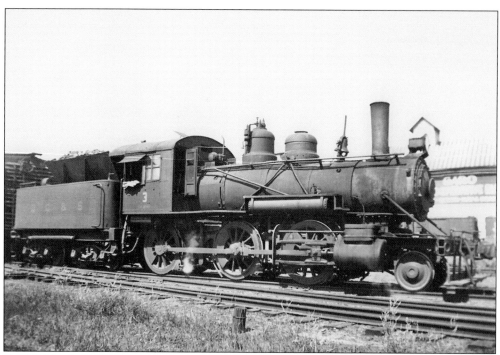

DC&S No. 3 *Old Jerry* switches cars at Caro around 1932. The engine was named after her engineer, who had once run traction engines as his main qualification for steam operation. Like much of DC&S's equipment, this locomotive came second hand from the Detroit & Mackinac Railway. (Photograph by Bob Gray, courtesy of George Y. Duffy Jr. collection.)

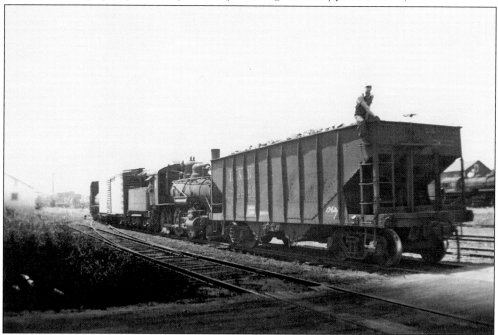

The No. 3 switches a hopper while the brakeman keeps an eye out. This photograph shows classic short-line railroading at its best. (Photograph by Bob Gray.)

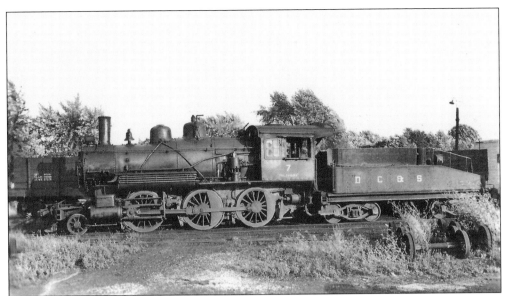

The Detroit, Caro & Sandusky loved to name its locomotives, and this one is no exception. *The Panama* was so named because it was originally used for the construction of the Panama Canal. Upon completion, many of these locomotives were sold back to the states, and this one was purchased by the DC&S.

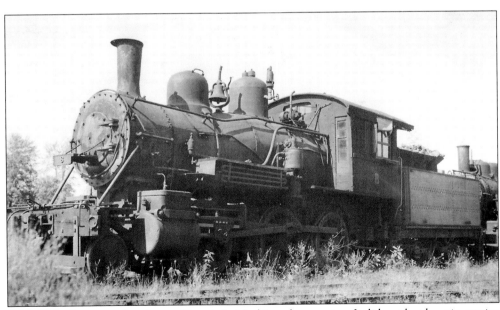

DC&S No. 8 was another former Detroit & Mackinac locomotive. It did not last long in service and was relegated to the deadline in Caro as a parts supply fairly early on.

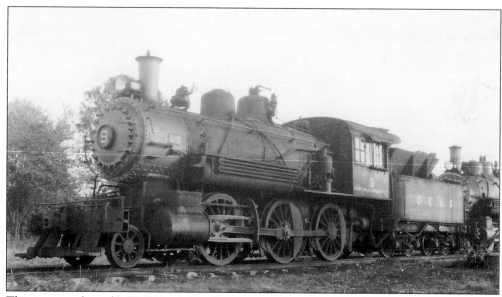

This is a rare shot of DC&S No. 9. Similar in size to her sisters Nos. 8 and 7, she was taken out of service in the mid-1930s.

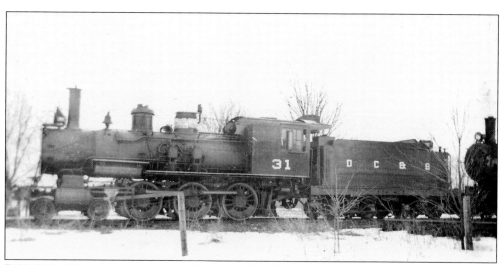

DC&S No. 31 appears in storage at Caro around 1935. Like many of the railroads in the Great Depression, numerous DC&S locomotives were put into storage when traffic no longer warranted their use.

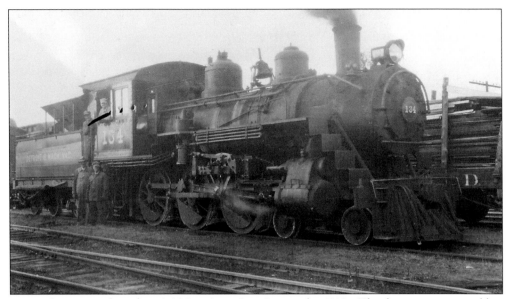

A proud crew stands with 4-6-0 No. 134 at Bay City in the 1910s. This locomotive was sold to the Detroit, Caro & Sandusky when the D&M dieselized after World War II. The tender shows the modification made to many of the D&M 4-6-0s, with an extended coal bunker built to reach the newer coal docks at Tawas.

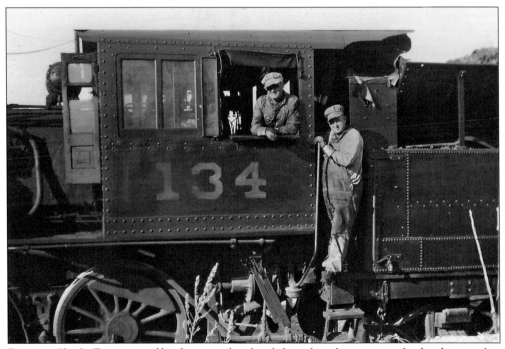

Engineer Charlie Ferguson and his fireman take a break from their duties to pose for the photographer in this late-1930s image. Ferguson, who had been a section hand, rose to the rank of engineer simply because he was the only one with any experience running anything steam powered. In his case, it was a farm traction engine.

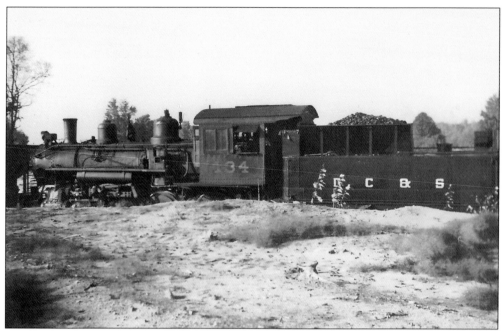

Here is another view of the fireman's side of No. 134 switching at Caro. Note how high the surrounding bluffs are to the cab of the engine.

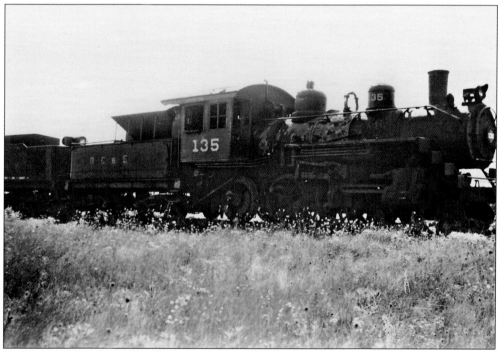

Ex–Detroit & Mackinac No. 135 sits with part of her boiler jacketing removed in the deadline at Caro. Purchased along with No. 134, she ran just a short time before being retired. She served as a valuable parts source for No. 134 for another decade.

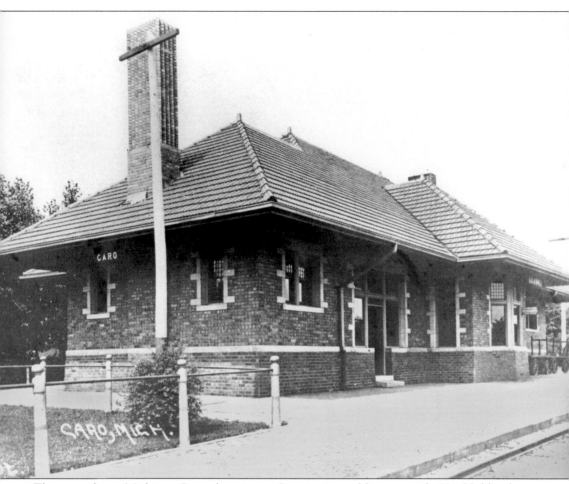

The magnificent Michigan Central station at Caro is pictured here around 1920. Unlike the Detroit, Caro & Sandusky, which was constantly buying second-hand equipment and scraping together pennies to keep going, the Michigan Central had the full support of its Vanderbilt-backed parent, the New York Central. This proud little station lasted into the 1950s, when it was torn down and replaced by a Michigan State Police post. It too was torn down, and only the cornerstone for this station remains at the site now.

Bob (left) and John Gray pose at the offices of the Detroit, Caro & Sandusky in Caro in the late 1940s. Much of what is known of the DC&S and its operations today are thanks to Bob's foresight in preserving its history. (Photograph by Bob Gray, courtesy of George Y. Duffy Jr. collection.)

These are the same offices shown in the photograph above along with an ex–Lake Shore & Western boxcar and one of two cabooses the DC&S owned, both of Detroit & Mackinac heritage. (Photograph by Bob Gray.)

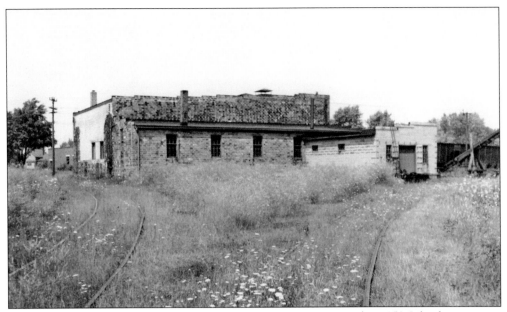

Here is the Detroit, Caro & Sandusky roundhouse at Caro in September 1950. Like the surviving (as of 2011) roundhouse at Port Huron, this was designed and built by William Boyd during the Handy Brothers ownership of the railroad. Like Port Huron's, it sits in a wye as well but in almost the exact reverse with the doors opening to the opposite end.

Pictured here is the DC&S roundhouse looking east. Compare this with the PH&D roundhouse in chapter three, and the mark of William Boyd's handiwork is apparent.

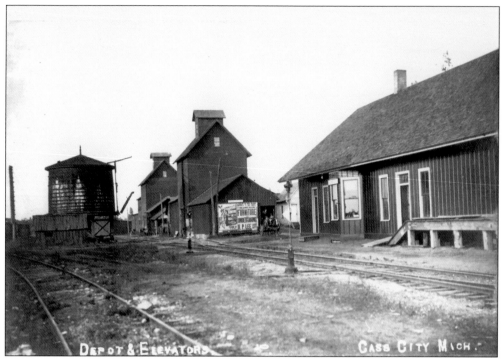

The original depot at Cass City is shown here around 1900. Originally built for the Pontiac, Oxford & Port Austin Railway, it was similar to several other stations on the "Polly-ann."

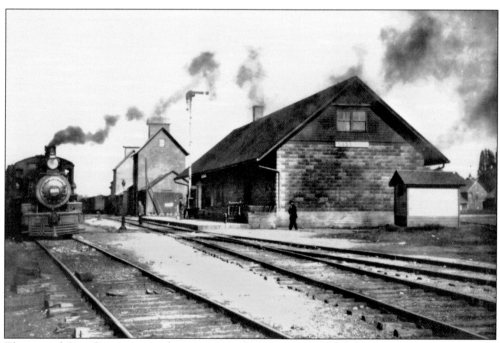

The second Cass City station is shown in a similar view around 1915. By this point, Cass City had reached a junction status, as the Detroit & Huron branch split off from here to reach Bad Axe.

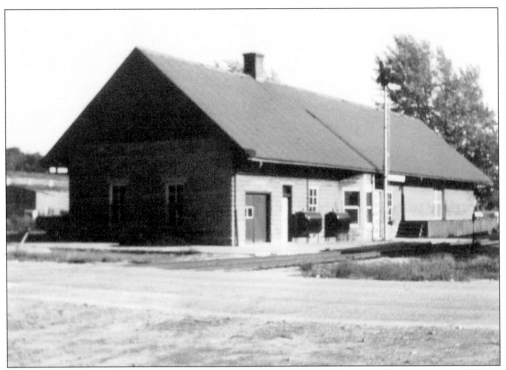

The Cass City station appears in its final incarnation. Although one would assume it would have survived longer than its wooden counterparts, this was not the case. It was gone by the early 1980s, a victim of the insurance world in that its concrete construction meant it could not be moved from the right-of-way.

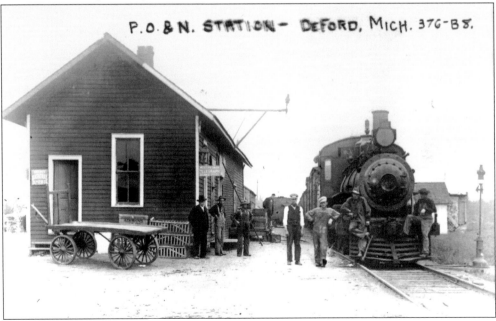

P. O. & N. STATION - DEFORD, MICH. 376-B8.

A Pontiac, Oxford & Northern crew waits at the station at Deford just north of Cass City. Sadly, nothing remains here today.

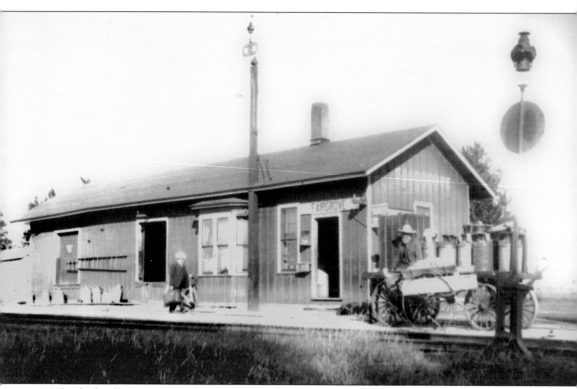

A load of milk cans awaits the daily trains from Saginaw and Bad Axe at Fairgrove sometime before World War I. Note the extra-high order board and the ladder attached to the side of the station, which was needed to reach the order board from the roof to adjust its lamp. Although this order lamp is almost ridiculously high, confusion by train crews with the high switch stands here most likely created the necessity for the change.

The Kind We Raise In *Gagetown, Mich.*

A.T. & S.F. RY. 2010.

This humorous postcard shows the growing prowess of local potato farmers in the Gagetown area, located on the Grand Trunk's Cass City sub. Those two probably could have made French fries for the whole town!

LOOKING WEST
KINGSTON MICH

Pictured here is a bird's-eye view of the village of Kingston on the Grand Trunk's line to Caseville looking west. The road running east to west is now M-46, the main truck route across the Thumb from Saginaw to Port Sanilac.

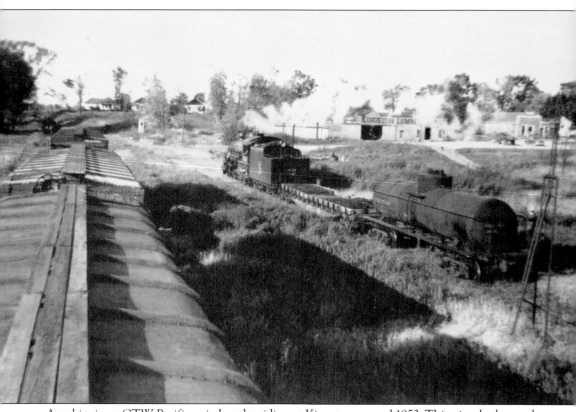

An ubiquitous GTW Pacific switches the siding at Kingston around 1953. This view looks north toward Pigeon and Caseville. (Photograph by Bill Miller.)

Seemingly half the community has come out to pose for the photographer at the PM depot at Mayville.

The station at Mayville is pictured as it looked in the 1990s after having been relocated to a park just south of its original location on M-24.

Here is another view from slightly north of the previous location showing the Millington Grain Company elevator and a small portion of the community.

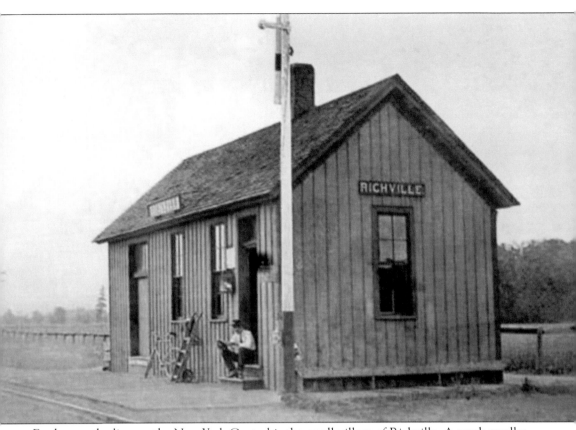

Farther up the line on the New York Central is the small village of Richville. A much smaller affair, it mainly served farmers of the area and was never much of a passenger stop.

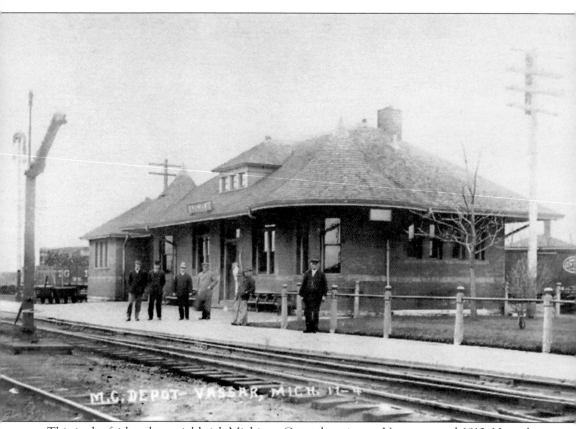

This is the fairly substantial brick Michigan Central station at Vassar around 1910. Note the Fairbanks-Morse water plug across from it, used to fill steam locomotives. Once commonplace, they are quite rare today.

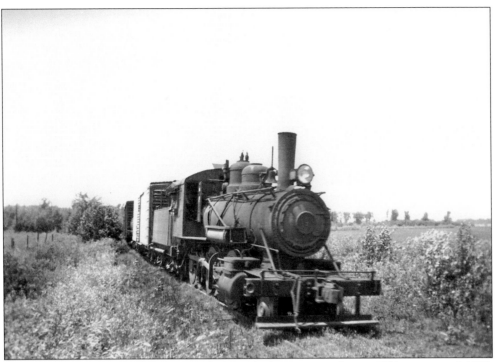

DC&S No. 3 nearly cuts her own path through the overgrowth near Wilmot around 1932. (Photograph by Bob Gray.)

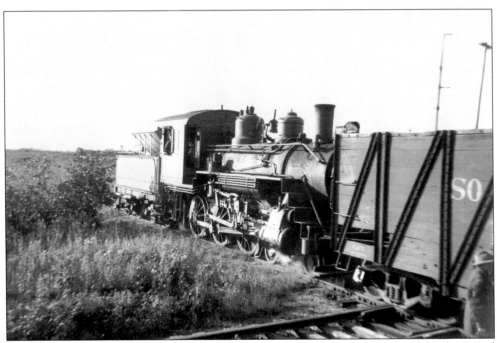

The same No. 3 leads a Southern Railway sugar-beet gondola across the diamond with the Grand Trunk in the early 1930s. This car is most likely being switched for interchange, hence why the locomotive is in reverse. (Photograph by Bob Gray.)

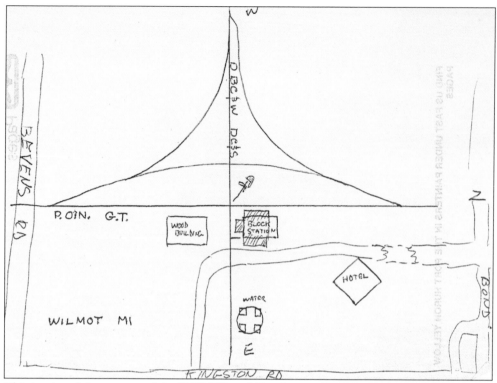

This is a hand-drawn map of the DC&S/Grand Trunk interchange at Wilmot. Sadly, nothing else of railroad heritage shown on this map survives today.

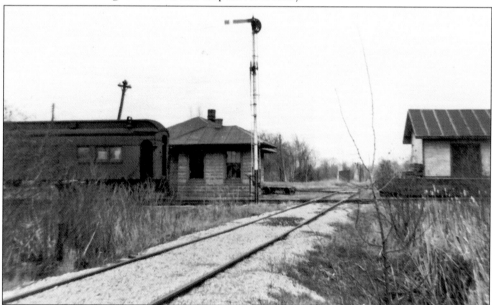

This image is a fitting end to the book. The end of the Grand Trunk local heading south to Imlay City passes the joint DC&S and GTW diamond at Wilmot. The DC&S (in the foreground) was abandoned in 1953. The station shown here lasted as a gutted shell into the 1970s. The GTW lasted until 1993, and nothing else survives but a station sign in the author's collection.

# BIBLIOGRAPHY

Dixon, Thomas W., Jr. and Arthur B. Million. *Pere Marquette Power*. Alderson, WV: Chesapeake & Ohio Historical Society, 1984.

Dorin, Patrick C. *Grand Trunk Western*. Burbank, CA: Superior Publishing Company, 1977.

Foss, Charles R. *Evening Before the Diesel: A Pictorial History of Steam and First Generation Diesel Motive Power on the Grand Trunk Western Railroad, 1938–1961*. Boulder, CO: Pruitt Publishing Company, 1980.

Gaffney, Thomas Jay. "The Changing Role of the Railroad and its Effects on the Thumb Region of Michigan." Master's thesis, Clemson University, 1999.

George Y. Jr. Duffy private collection.

Kelly, Michael C. *Rails around Michigan: The Wolverine State in Days Past*. China: K&G Productions, 2010.

Million, Arthur B. and John C. Paton. *The Pere Marquette Revenue Freight Cars*. Mukilteo, WI: Hundman Publishing, 2001.

Paton, John C. *Chesapeake & Ohio BL2 Diesels*. Clifton Forge, WV: Chesapeake & Ohio Historical Society, 1991.

Port Huron Museum Collection.

Schramm, Jack E., and William H. Henning. *When Eastern Michigan Rode the Rails II: Detroit to Port Huron*. Glendale, CA: Interurban Press, 1986.

VanderYacht, Clifford. *The Pere Marquette in 1945*. Alderson, WV: Chesapeake & Ohio Historical Society, 1991.

# Discover Thousands of Local History Books
## Featuring Millions of Vintage Images

Arcadia Publishing, the leading local history publisher in the United States, is committed to making history accessible and meaningful through publishing books that celebrate and preserve the heritage of America's people and places.

Find more books like this at
**www.arcadiapublishing.com**

Search for your hometown history, your old stomping grounds, and even your favorite sports team.

Consistent with our mission to preserve history on a local level, this book was printed in South Carolina on American-made paper and manufactured entirely in the United States. Products carrying the accredited Forest Stewardship Council (FSC) label are printed on 100 percent FSC-certified paper.

**MADE IN THE**

 **USA**